POP ART
A New Generation of Style

R I C H A R D L E S L I E

TODTRI

Copyright © 1997 by Todtri Productions Limited.
All rights reserved.
No part of this publication may be reproduced, stored in a
retrieval system or transmitted in any form by any means
electronic, mechanical, photocopying or otherwise, without
first obtaining written permission of the copyright owner.

This book was designed and produced by
Todtri Productions Limited
P.O. Box 572, New York, NY 10116-0572
FAX: (212) 695-6988

Printed and bound in Singapore

ISBN 0-7651-9223-3

Author: Richard Leslie

Publisher: Robert M. Tod
Editorial Director: Elizabeth Loonan
Book Designer: Mark Weinberg
Senior Editor: Cynthia Sternau
Project Editor: Ann Kirby
Photo Editor: Laura Wyss
Production Coordinator: Jay Weiser
Desktop Associate: Paul Kachur
Typesetting: Command-O Design

Picture Credits

The Andy Warhol Foundation for the Visual Arts 5, 59, 60–61, 62–63, 65

Collection of Edwin Janss, Thousand Oaks, California 34

Collection of Mr. and Mrs. Morton G. Neumann, Chicago 23

Collection Watson Powell, Des Moines, Iowa/Art Resource, New York 118

Corbis-Bettmann, New York 12, 22, 29, 39, 58, 61 (top), 81

The David Hockey No.1 U.S. Trust 126, 127

The Phyllis Kind Gallery, New York and Chicago 79, 80, 82–83

The Kobal Collection, New York 64

Kröller-Müller Museum, the Netherlands/Art Resource, New York 38

Los Angeles County Museum/Art Resource, New York 42

Musée Cantini, Marseille/Art Resource, New York 98

Musée National d'Art Moderne, Paris/Art Resource, New York 47, 102

The Museum of Modern Art, New York 6–7, 8–9, 13, 14, 16, 19, 25–25, 26, 27, 31, 32, 33, 35, 36–37, 44, 45, 46, 48 49, 50, 54, 55, 66, 67, 68, 69, 70, 71, 72–73, 74, 75, 76, 86, 87, 88–89, 90, 91, 92, 94, 95, 97, 99, 100–101, 104–105, 106, 107, 109, 111 (top), 113, 116

National Gallery of Canada, Ottawa 15

National Museum of American Art, Smithsonian Institution, Washington, D.C. /Art Resource, New York 28, 52, 56–57, 77, 78

The Newark Museum, New Jersey/Art Resource, New York 51

Nam June Paik and Holly Solomon Gallery, New York 108

Private Collection/Art Resource, New York 10, 103

Solomon R. Guggenheim Museum, New York 17

The Tate Gallery, London/Art Resource, New York 18, 20, 40–41, 43, 53, 110–111, 112, 114–115, 117, 119, 120–121, 122, 123

Wallraff-Richartz-Museum, Cologne/Art Resource, New York 96

The Whitney Museum of American Art, New York 84–85

Whitworth Art Gallery, University of Manchester/Art Resource, New York 124–125

CONTENTS

INTRODUCTION

Pop art was an international movement in the visual arts considered to mark a more fundamental shift in the nature and understanding of modern culture. Its roots lie as much within societal changes as within the dominant tendencies of the art world at mid-century. Although it is true that most significant art possesses strong resonances with the cultural conditions from which it emerged, the relationship seems more dramatic in the case of Pop art because the changes in culture signaled by the movement were profound and exist today at the close of the century. Simply put, Pop art accepted, symbolized, and was acknowledged because of the simultaneous growth of a new sense of "popular culture." But what did "pop" mean in art and culture?

Pop was pure anathema to the critics of the art world, who initially rejected much of it as kitsch postcards from the low end of culture. But neither is it so simple as an argument between high and low concepts of art and culture. We better understand today, albeit only recently, that the pop in popular culture represented the appearance of a new media culture as a major characteristic of the second half of the twentieth century. And although it is very difficult to know precisely what "Pop" art is, no one doubts its strong relationship to the emergence of these new conditions in the early 1960s. But it also emerged from an alternative history of modern art and in redefining this history rewrote the future.

What was viewed as the triumph of modern art in America in the late 1940s and into the 1960s—the heroic movement known as Abstract Expressionism and its offshoots—was acknowledged to form from the conjunction of American attitudes with the great movements in European modern art from the first half of the century: Expressionism, Cubism, abstraction, and Surrealism. But at the same time a few American artists ignored or selectively read large portions of this history while returning to the earlier movement of Dadaism as a touchstone. In so doing they provided basic tenets for Pop art. But neither was Pop art limited by and to their influences. Indeed, the single word *pop* enfranchises only a small part of the complex and intriguing situation. It drew from a wider, more diverse mix of art and cultural attitudes that in turn form the nucleus of art forms and cultural conditions today labeled *postmodern*.

Pop art is commonly viewed as representative of the developments in New York City in the early 1960s. But many of the Pop artists were active first in art events, such as Happenings, that provided an interlocking basis for the vast proliferation of other art forms—from performance art to music, theater, and dance. Not only does this tell us that Pop art cannot be easily inscribed within such lines as painting but that, at its heart, the movement housed a major and powerful contradiction. The movement that was repeatedly reported to celebrate the sense of the object, particularly the object within a new sense of culture seen in terms of everyday life, actually relocated the site of art

FOLLOWING PAGE:

F-111

JAMES ROSENQUIST, 1964–65; oil on canvas with aluminum, 10 x 86 ft. (304.8 x 2621.3 cm). Purchase, The Museum of Modern Art, New York. © 1997 James Rosenquist/Licensed by VAGA, New York, N.Y. Typical of Pop artists, Rosenquist spoke of forms and the equality between them, scarcely acknowledging that his were among the few political paintings in Pop art. Designed to cover all four gallery walls as an environment, the fifty-one panels of *F-111* also disconnect images in the style of media information.

Great American Nude, 2

TOM WESSELMANN, 1961; synthetic polymer paint, gesso, charcoal, enamel, oil, and collage on plywood; 59⅝ x 47½ in. (151.5 x 120.5 cm). Larry Aldrich Foundation Fund, The Museum of Modern Art, New York. © 1997 Tom Wesselmann/ Licensed by VAGA, New York, N.Y. Wesselmann's series of nudes begun in 1960 were originally intended to critique the presentation of women as sex objects in advertising, with blank faces and sexual body parts prevalent. However, after years of reproduction, they raise the question that haunts all of Pop art— that of complicity.

away from the object into the audience and the mind's eye. Pop art—as is more recognized today than in its own time—was a part of Conceptual art.

The problems of Pop's diversity and definition in the United States are also addressed by considering what other parts of the country hosted in the name of Pop art. The West Coast had two distinct schools—in Los Angeles and in northern California—distinct from one another yet quite different from that of New York. The same can be said of the artists and art in Chicago, which has always gone its own way.

Turning to the complexities in Europe, the term Pop art tells little in the face of the indigenous sense of "new realism." Here, too, much of the energies of the artists entered into a wide range of conceptual as well as physical undertakings. As in New York, but in a far more pronounced manner, the realities of materialism co-existed with the assertion that art exists as an idea. The conceptual nature of European art made apparent in the 1960s has continued to mark much of its development and strength. Was this then also Pop art?

The reconstruction of this history through ideas tells not only quite different though interlocked histories of modern art; it also shows that the conditions of our culture have changed dramatically. Looking at the art of this period is to observe both ourselves and the nature of our times with a new clarity.

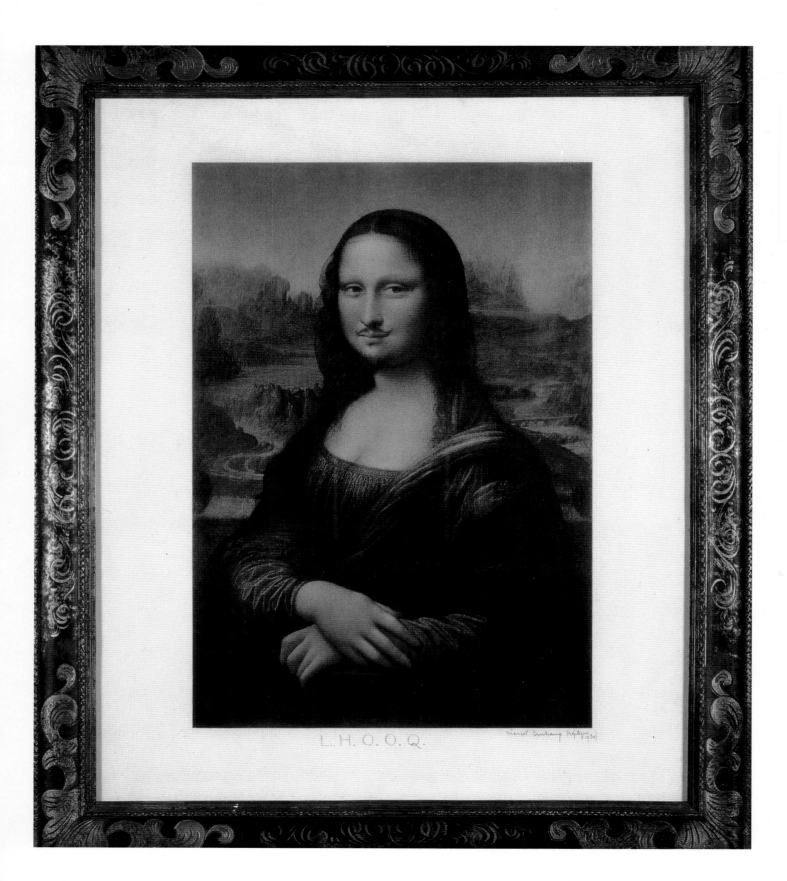

PRIOR TO POP

Histories can be understood as the present time casting an eye to the past to select and justify its current state of affairs. Thus there are at any given moment in time numerous potential futures and pasts, depending on the reader. No one could have foreseen the complex ways in which Pop art would "read" the past to form its moment. As it read past European art movements, emphasizing some while ignoring others whose influence had been dominant, Pop art also rewrote the future into a configuration that lasted well beyond its own moment. It was motivated by a change in the conditions of culture still extent today.

Dada

Dada was an international art movement developed in Europe as moral, social, and political outrage against the insanity of World War I. From its very beginnings it was an art form grounded in cultural conditions. Dadaists saw nihilism as the strategy that best emulated the conduct of "civilized" states at war. And although there were as many "dadaisms" (the word was a non-sense syllable) as there were urban centers for it, as a movement these artists generally evolved a set of ideas that offered a new alternative to current notions about what constituted modern art. They established a model for art as responsive—but not responsible—to the real world.

World conditions made certain artists disgruntled with the then dominant modernisms of geometric art, like Cubism and its abstract variants, as inadequate artistic responses. In so far as the Dadaists remained painters at all, they frequently chose machine imagery and a faith in technology which they used to protest the old and to affirm either destructive or optimistic faith in a technological future. Many gave up painting entirely for new forms of art making—such as constructions, collages, and photomontage—or to explore alternative and less static art forms, such as kinetic sculpture, performance, and film.

Marcel Duchamp was perhaps the most radical of all, giving up first painting, around 1913, and finally art in general in the 1920s. In 1913 he began picking up objects from the world around him and either combining them into unique constructions or simply announcing them as art. His move was perhaps influenced by the Cubist collages in Paris that contained bits of the topical world, such as newspaper clippings, to confront in a new way age-old relations between art and reality. However, the Cubist collages relied on the continued tension between art and reality. It was great and creative fun to mix them but everyone understood that they would remain separate worlds.

Duchamp's move challenged Cubist assumptions about the proper place for objects, and established a cascading idea that gathered importance as the century progressed. Similar issues and arguments mark the development of Pop art some fifty years later.

In works like *L.H.O.O.Q.*, Duchamp's penciled mustache drawn on a reproduction of the high-culture icon, *Mona Lisa*, by Leonardo da Vinci, lowered the work to street level. It was

L.H.O.O.Q.

MARCEL DUCHAMP, 1919; reproduction of the Mona Lisa *altered with a pencil, 7¹/₂ x 5 in. (19 x 12.7 cm). Private collection, New York. © 1997 Artists Rights Society (ARS), New York/ADAGP, Paris/Estate of Marcel Duchamp.* In Duchampian terms, this is an assisted ready-made, and like most of his work it operates on several levels of meaning. It desecrates the "sacred"; it marks the subject by title as a sexual woman; it delineates, via the artist, a cross-construction of gender roles. Such transformations were to be of concern to Pop artists.

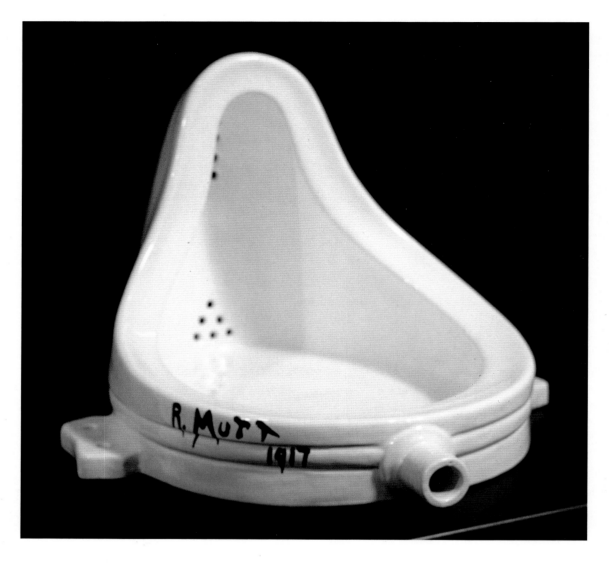

Fountain (by R. Mutt)

MARCEL DUCHAMP, 1917 (original lost; 1964, third version); urinal turned on its back; 24 in. high (60.9 cm). Bettmann Archive, New York. © 1997 Artists Rights Society (ARS), New York/ADAGP, Paris/Estate of Marcel Duchamp.

Designed to test the policy limits of an art exhibition, Duchamp's most outrageous ready-made is an enduring test of the limits of art. The acceptance of objects in the world as art aligned with John Cage's influence on the attitude and direction of visual art.

certainly a Dadaist gesture of nihilism and protest but it was even more. The phonetic sound of the letters vaguely recreated a phrase in French that referred to the subject as having a sense of raw sexuality. Duchamp had sexualized the asexual—"art."

His *Fountain* of 1917 was perhaps the most outrageous of a number of "found" objects proffered as a work of "art." It was originally submitted under the signature "R. Mutt" to test the liberal acceptance policies of an art exhibition in New York, where the jury rejected it. But over time it passed beyond the singular issue of Dada protest and is accepted today as art, much as has Duchamp's notion that art can be a matter of choice and attention.

It was Duchamp's ideas that formed an entire aesthetic which, combined with his periodic presence in New York throughout the century, eventually exerted a profound influence on younger artists concerned with an alternative to Abstract Expressionism. Today we retain the word *neo-Dada* for the revitalization of his ideas which developed through the 1940s and '50s with Robert Rauschenberg, Jasper Johns, the composer John Cage, and the choreographer Merce Cunningham. Some refer to these individuals and ideas as "proto-Pop," a piece of jargonese that points up the historical relation very nicely, even where the phrase is inaccurate.

Surrealism

The Surrealist movement in the 1920s and '30s took over much of the membership and ideas of the Dada movement and brought many of them, with their modifications and additions, to the United States around the time of World War II.

Surrealist ideas were utilized by the American Abstract Expressionists without credit to or recognition of their Dada roots. Thus Jackson Pollock's sweeping gestural strokes across the canvas in the late 1940s were likely inspired by and certainly interpreted as the application of Surrealist ideas. These artists had conjoined Sigmund Freud's concept of the unconscious to their belief in artistic access to it through the use of "automatic" techniques. For a poet this meant the continuous flow of words, often from a trance state; for a painter, the continuous physical movement of a hand or arm drawing a line would create the same conduit. Thus Pollock's all-over skein of gestures was read as a record of process more than form-making, one directed or produced by the unconscious.

Dadaists had accepted chance as both a destructive and creative principle, and chance encounters were integrated into the Surrealist aesthetic with the understanding that there was a kind of psychic resonance between the artist-finder and the object or thing found. Thus the found object of Duchamp's Dadaism took on a psychological foundation, and the Surrealists strengthened the role of "objects" among the avant-garde. Objects, too, would play a significant role in the understanding of art for the Pop artists of the 1960s in Europe and the United States.

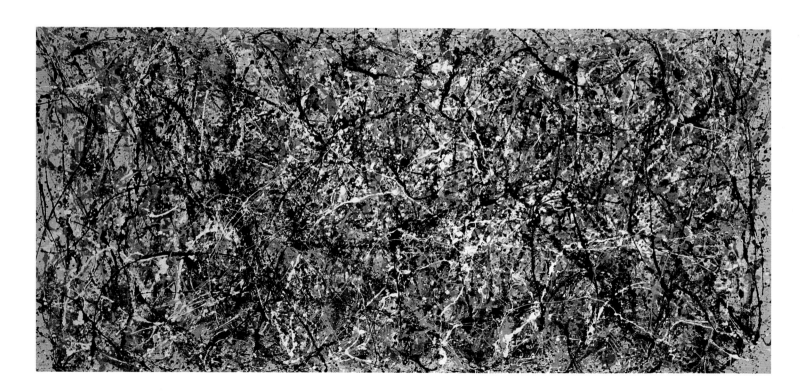

One (Number 31, 1950)

JACKSON POLLOCK, 1950; oil and enamel on unprimed canvas; 8 ft. 10 in. x 17 ft. 5⅝ in.

(269.5 x 530.8 cm). Sidney and Harriet Janis Collection Fund (by exchange), The Museum of

Modern Art, New York. ©1997 Pollock-Krasner Foundation/Artists Rights Society (ARS), New York.

The neo-Dadaists and Pop artists apparently rejected, even mocked, the passion and engagement of Pollock's and other Abstract Expressionist's gestural brushstrokes. Yet many also admired the emphasis on art as a process even as they developed their own.

Object (Le Déjeuner en fourrure)

Meret Oppenheim, 1936; fur-covered cup, saucer and spoon; cup 4 3/8 in. (10.9 cm) diameter; saucer 9 3/8 in. (23.7 cm) diameter; spoon 8 in. (7.3 cm) long; overall height 2 7/8 in. (7.3 cm). Purchase, The Museum of Modern Art, New York. © 1997 Artists Rights Society (ARS), New York/Pro Litteris, Zurich.

The fusion of sexuality, humor, and scandal made Oppenheim's 1936 submission to the New York exhibition the perfect Surrealist object. The Surrealists insisted on the use of the objective world as the arena for their interest, locating ruptures through humor and irony.

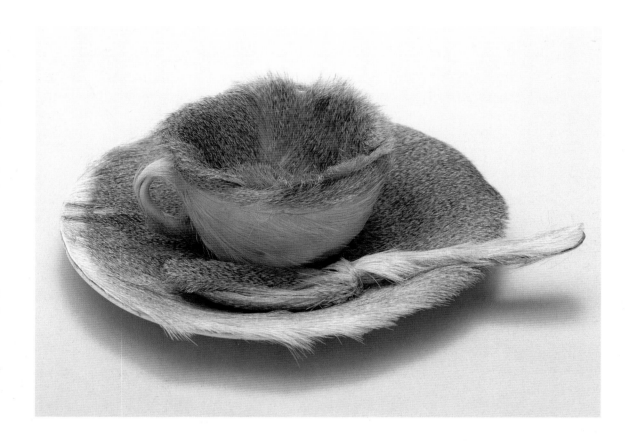

The significance and multiple possibilities of Surrealist objects was brought home to American audiences as early as 1936, when Meret Oppenheim, one of the more sexually liberated Surrealists, showed her *Object* at the Museum of Modern Art in New York. The visual humor of a fur-covered cup, saucer, and spoon is equaled by the conceptual and sexual puns implicit in the stirring and drinking. Audiences were "shocked."

The issue of transformation played a major role in Surrealism, as it would in Pop art. This meant not simple visual illusionism with one thing resembling another, but that one thing in the world could have multiple or an overly determined array of meanings. The artists recognized that through creativity they could provide a new context that transformed meaning. It was an objectified creativity in the sense that it arose not from an interior process of making by the artist—the way many conceive of "normal" art-making as a kind of form-giving procedure—but by finding elements and moments that exist in the world. Such an axiom is a central tenet in neo-Dada and Pop art. The Abstract Expressionists would "make" or create from a struggle within their psyche; the Pop artist does not impose will by refashioning materials to the same degree, preferring to accept objects in the world while providing a new context.

The American Surrealist Joseph Cornell serves as an example. He collected objects obsessively all his life, much the same as people collect mementos as they travel. Under the influence of the Surrealists, he restructured his private accumulations, placing them in boxes, and transforming them into an art of charged and poetic repositories of memory. The transformation was primarily accomplished not through the manipulation or refashioning of materials but rather by restructuring the context. Pop artists would understand art and transformation in the same way.

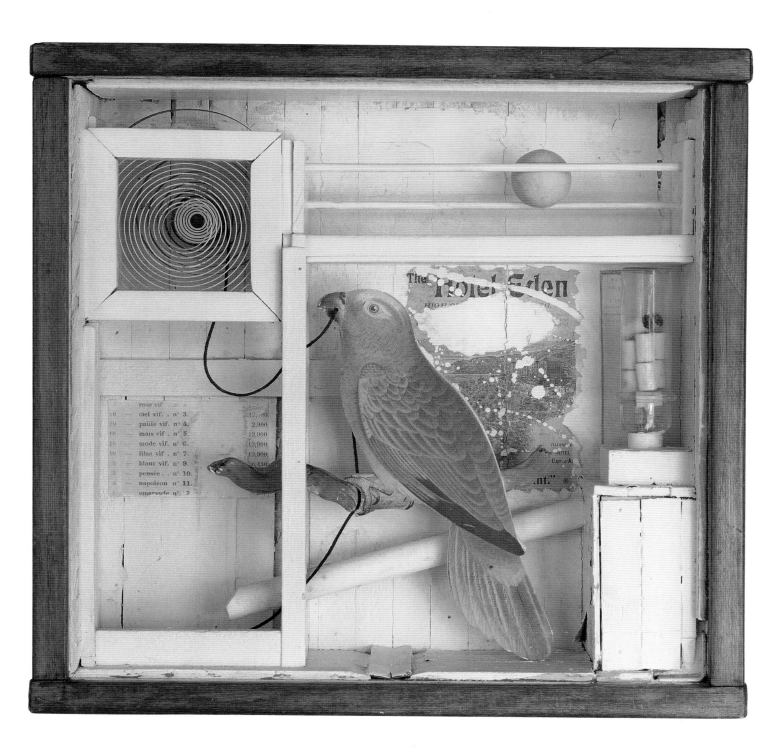

Hotel Eden

JOSEPH CORNELL, 1945; assemblage with music box; 15 x 15⅝ x 4¾ in.

(38.3 x 39.7 x 12.1 cm). National Gallery of Canada, Ottawa.

One of the few, true American Surrealists, Cornell never joined the movement despite his great admiration for them and his immense gift for constructing poetic objects from collected debris and personal dreams. His love of everyday objects was to find an echo in various forms of Pop art.

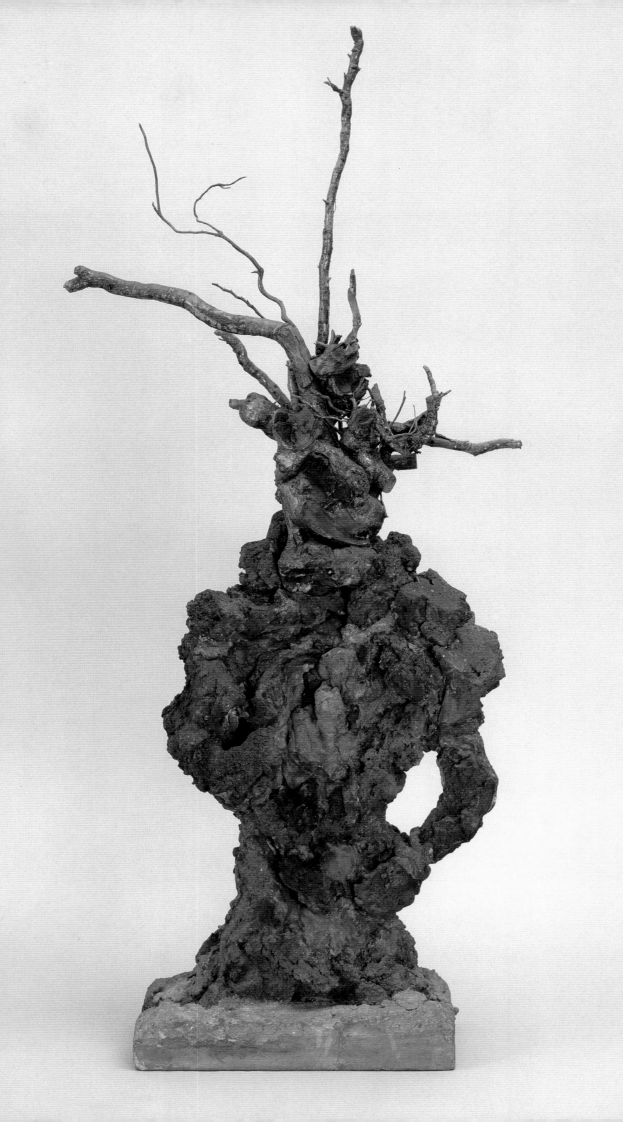

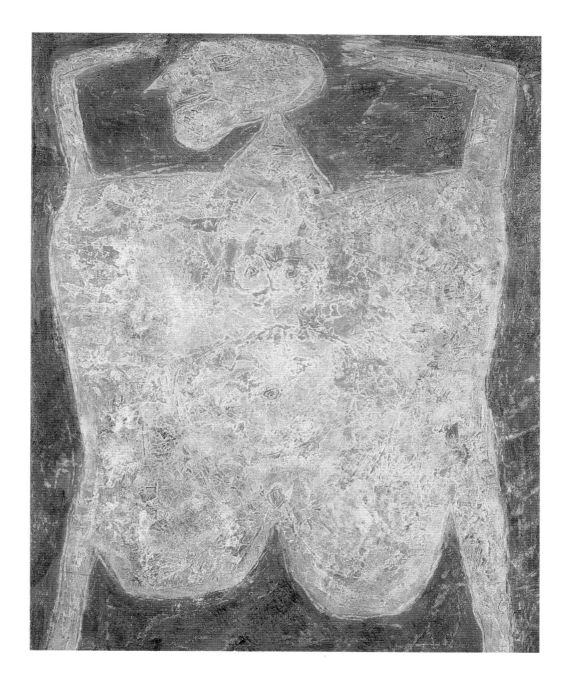

Triumph and Glory (Corps de Dames)

JEAN DUBUFFET, 1950; oil on canvas; 51 x 38 in. (129.5 x 96.5 cm). Solomon R. Guggenheim Museum, New York. © 1997 Artists Rights Society (ARS), New York/ADAGP, Paris. Like Bacon, Dubuffet was much admired for recording the shock of war through the raw-material surfaces and primitive markings he shaped into a philosophy of art which he termed Art Brut. The "brutal" application of oil, often mixed with sand, and its crude handling inscribed a new image of man.

The Magician

JEAN DUBUFFET, 1954; from the Petites statues de la vie précaire series; slag and roots; 43½ x 19 x 8¼ in. (109.8 x 48.2 x 21 cm). Gift of Mr. and Mrs. N. Richard Miller and Mrs. Alex L. Hillman and Samuel Girard Funds, The Museum of Modern Art, New York. © 1997 Artists Rights Society (ARS), New York/ADAGP, Paris. Dubuffet liked to speak of the chance finding of materials yet he had a purposeful agenda. His use of "slag" for sculpture worked as an emblem; the discard of impurities on behalf of the purity of civilization became the source of an art that, for him, could only emerge from the impure.

Art Brut

Surrealism was a leading aesthetic in Europe between the world wars but during and after World War II only a few artists responded with an art form that spoke directly to the damage of the war experience. One was the wine merchant Jean Dubuffet, a confidant to many of the Surrealists.

Dubuffet developed an art and a set of ideas he titled *l'art brut*—raw art—that encompassed a visceral, physical response and a crudeness that paralleled both human conduct and the physical destruction in war-torn Europe.

17

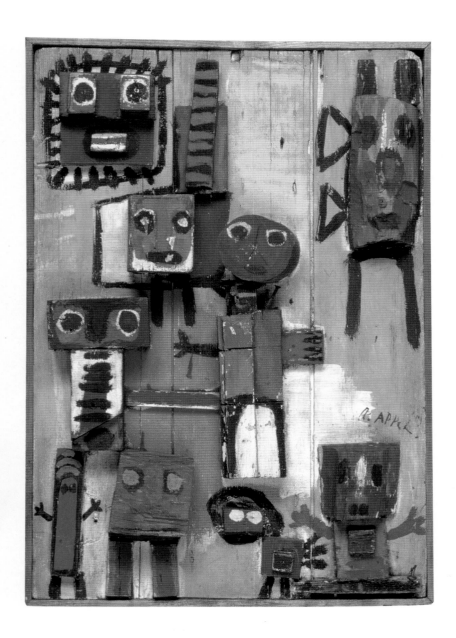

Questioning Children

KAREL APPEL, 1949; oil on wood relief; 34³/₈ x 23¹/₂ x 6¹/₄ in.
(87.3 x 59.7 x 15.9 cm). The Tate Gallery, London. © 1997
Artists Rights Society (ARS), New York/Beeldrecht, Amsterdam.
In Europe figurative and abstract art commingled
on many fronts. Appel's mixture of found pieces
of wood roughly mounted to wall boards and
crudely applied paint on and around each figure,
as an untutored child might make, is an example
of such interaction. Spontaneity and abandon-
ment were paths for many to recover imagination.

He also collected the art of the untrained, the
"insane," and children, prizing as did the
Surrealists their supposedly more direct access
to creativity. For Dubuffet only these types of
people could be true artists; others were too
conventionalized, too distanced from the very
subjectivity that made them human. In his own
work he adopted crude drawings and raw rather
than finished materials, much of which was the
detritus of destruction. Only the impure—such
as the slag he used in his sculpture, in direct
opposition to Picasso's use of finished bronze—
could, he believed, testify to the new realities
of life's true condition: damaged.

Dubuffet—along with a select few of the
older artists such as Francis Bacon and Alberto
Giacometti—was admired by the younger,
emerging European artists because he reflected
rather than ignored the modern consequences
of life. These few older artists provided a phi-
losophy to help the postwar artists integrate
their own experiences into their work. One can
argue that because of the direct physical experi-
ence of the war and its aftermath "Pop Art" did
not develop in Europe simply because the
European art forms refer to a different set of
physical and emotional conditions. A sense of
new realism, literally *Nouveau Réalisme*,
emerged among European artists in the late
1940s and 1950s to include these senses of
physical and psychic damage.

This set of ideas would have a profound effect
on the art made in Europe during the 1960s,
and would resonate sympathetically with cer-
tain aspects of American Pop art. The conjunc-
tion is demonstrated in the claim that the first
group showing of the American artists who
would eventually be labeled "Pop" artists came
in a 1962 New York exhibition at the Sidney
Janis gallery, which showcased Europeans and
used the title from the Paris-based aesthetic,
"The New Realists." At that moment the two
sides of the Atlantic were recognized as deeply
related and emerging from *l'art brut* if not
from some other, more broad-based set of
cultural conditions.

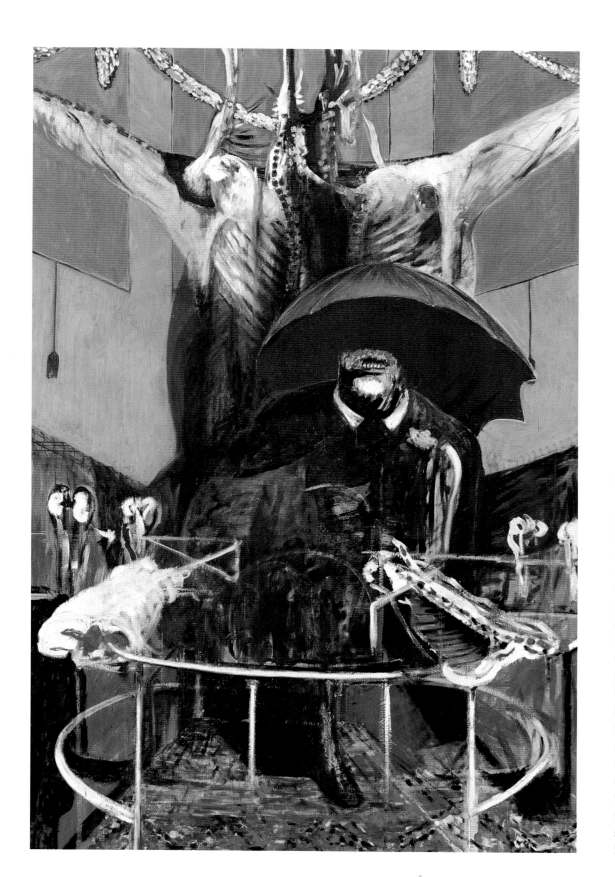

Painting

FRANCIS BACON, 1946;
oil and pastel on linen;
6 ft. 5⅞ in. x 52 in.
(197.8 x 132.1 cm).
Purchase, The Museum of
Modern Art, New York.
No one records the
results of World War
II's savage inhumanity
as does the English
painter Francis Bacon,
in large part because
he did not set out to
paint it. Setting slabs
of butchered meat
upon the flanks of
screaming human fig-
ures illustrates clearly
that war is merely a
symptom of a deeper
human condition.

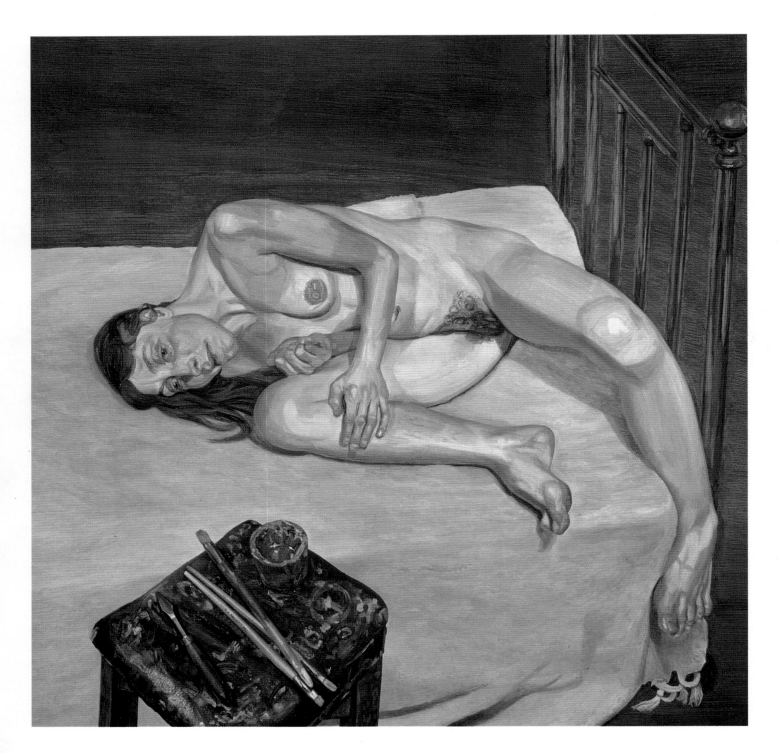

Naked Portrait

LUCIEN FREUD, 1972–73. The Tate Gallery, London.

Within Lucien Freud's work, considered a part of the revival of the figural tradition in the midst of abstraction, it is too easy to under-rate abstract qualities within the handling of the figure. He uses abstraction not to unify but to construct a figure; living flesh lovingly rendered or erotically posed is simultaneously dead on arrival.

Abstraction & Figuration in Europe

There was a strong and continuing modern tradition of abstract art in Europe, an argument for the purity of art that emerged in the early twentieth century. However, the challenges of post-World War II culture were better served through the human figure, albeit a damaged figure for a damaged life.

The same was true though to a different extent among Americans concerned with abstraction. Although the figure disappeared in the name of abstraction, much of the early and continuing struggles among Abstract Expressionists dealt with the figure or "figurative elements." This is an important point of recognition because eventually Pop art would assert its claim as heralding the return of the figure after the supposed dominance of abstraction. There is an obvious truth to this, but thinking of art and history as either/or—either figure or abstract—is neither accurate nor especially productive.

To see the artists temporarily aside from the restrictions of their movements, as sharing similar, broader currents, provides a better understanding of relationships and knits Europe to the United States without dismissing their differences. The trans-European movement known as CoBrA—an acronym formed from the first letters of its city centers: Copenhagen, Brussels, and Amsterdam—provides a good example.

The group's manifestoes and the work of Dutch CoBrA artist Karel Appel shared diverse and apparently contradictory themes. All members had passed through abstraction but many of them preferred figure painting. Their figures born of abstraction were not new simply for the sake of establishing a sense of newness, as is the traditional aim of the avant-garde, but the most effective form to express their postwar situation. Style, in the modern sense, was self-consciously ideological. To figuration and abstraction CoBrA conjoined expressive brush handling, wild colorations, elements from the low or popular culture, and

an admiration, like that of art brut, for materials found in everyday life and the naive sensibilities of children and folk artists. This impure approach to art was widespread in Europe, and despite the lack of direct war damage the United States shared many of these ideas.

Thus do the tortured and isolated figures of England's Francis Bacon show the condition of existential isolation and a sense of despair. More subtly portrayed are the figures of Bacon's countryman Lucien Freud, who had no relation to any of these movements but who painted figures that were apparently cold and aloof, like slabs of meat, and with such an insistent reality of physical presence in image and brushwork, that one is reminded of the simple, existentialist response to life: we exist first and all else follows.

Sometimes subjectivity means simply being there, and for Freud the *being* he spoke of for his figures was in the "abstract" quality of the paint as physical material. To understand such issues is to understand how figures can be objects and objects can be figures in the art of the 1960s both in Europe and in America.

Modernist Art in the United States: Abstractions & Signs

Despite the enthusiasm and antics of a small coterie, the arrival around 1915 in the United States of the European Dadaists Picabia and Duchamp had a limited impact. What elements of modernism were accepted into the American consciousness were the result of a process long and slowly built throughout the 1920s, when it was curtailed by the Depression and accepted conservative forms. Man Ray, one of the few American Dadaists, marked the moment by moving abroad in 1921 in recognition that the Europe he valued was not soon coming to the United States.

The 1913 exhibition in the New York Armory had pitted American conservatism and a robust home-grown realism against the conceits of modernist Europe, with the home

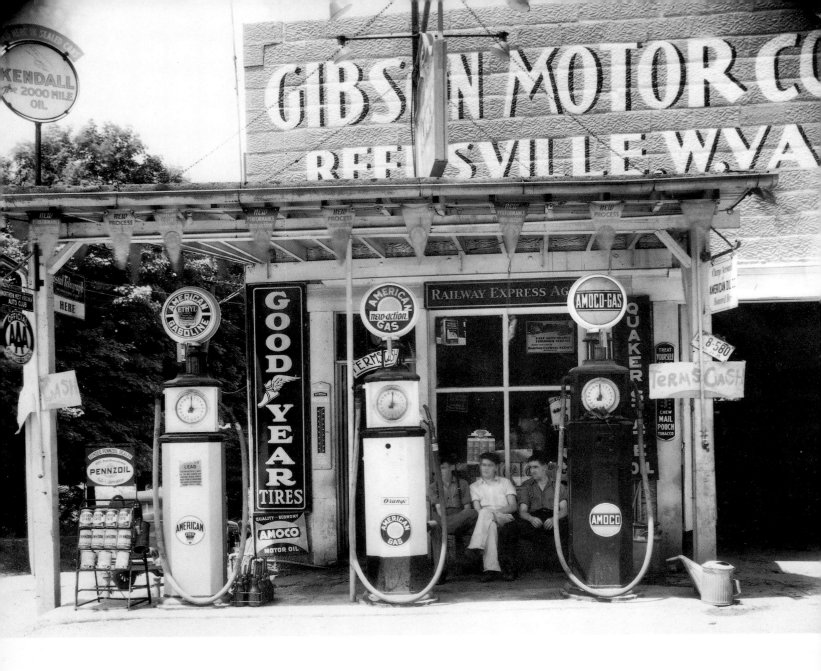

Small Town Filling Station and Auto Repair Shop

WALKER EVANS, 1935;
gelatin silver print;
8 x 10 in. (20.3 x 26.4 cm).
Corbis-Bettmann.

Evans, the socially committed photographer of the Depression, shared with a few modernist painters, such as Stuart Davis, a love for the signage of America and documented it as an integral part of American life. Pop artists would come to share the love and the documentation.

team winning the local game although eventually losing the world series years later. This is not to say there were not original American modernists developing at the time of the First World War. The paintings and philosophies of artists such as Georgia O'Keeffe and Arthur Dove, or the photographs of Paul Strand, applied an abstract vision derived from European modernism to their interest in nature and the real world in general with powerful results that kept the idea of modernism alive in the United States throughout the first half of the twentieth century. Such hybrids of abstraction and realism were relevant for the development of Pop art in both general and specific ways.

Stuart Davis has been given increased credit over the years as a major influence on young American Pop artists of the second half of the century for his life-long dedication to a general sense of modernism, which in his case meant

Cubism, while altering it to incorporate an American subject matter. Early works, such as *Lucky Strike* (1921), fashioned the physical elements of an American cigarette package into a flat Cubist design. Later works, such as *Visa* of 1951, show his retention of the flat Cubist grid of color planes as a general frame for the garish colors and explosive words he now used to characterize the brashness of American character and commercial culture.

A quiet contrast comes in the black-and-white photographs of socially committed photojournalist Walker Evans, who also used an abstract vision of design in combination with his documents of store fronts and road and advertising signs in the 1930s. His "straight" pictures of country towns and urban centers emblemized the nature of the nation for whom "things" and transactions were the core of the American experience. Such a vision, shared by

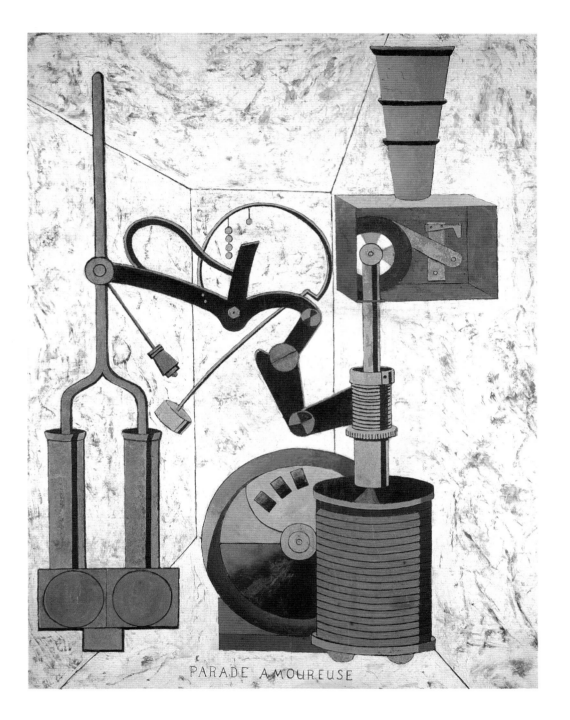

Amorous Parade

Francis Picabia, 1917; oil on board; 37 x 28 in. (95.25 x 72.39 cm). Collection of Mr. and Mrs. Morton G. Neumann, Chicago. © 1997 Artists Rights Society (ARS), New York/ADAGP, Paris. The absurdity of the reduction of human beings and their social conventions into mechanical parts was typical of Dadaism, and Picabia never tired of prodding the sexual practices of society by picturing them so.

two such unlikely sources as Davis and Evans, is the nucleus of a "pop" vision, a formal modernist design wedded to the realism and fragmented facticity of American subject matter and tied to the cultural conditions from which it emerged.

However, it is also a conservative if unique vision typical of the United States. Both American modernism between the wars and the postwar Pop art may be seen two ways—as historically radical but, in the long view, fitted neatly within the more conservative traditions of American culture, one that favors figures and common if commercial life. The basic conservatism of the Americans was evident throughout the development of avant-garde ideas, whether among public documentarians of the '30s or as a private vehicle for public taboos like Andy Warhol's suppressed homosexuality in the 1960s and '70s.

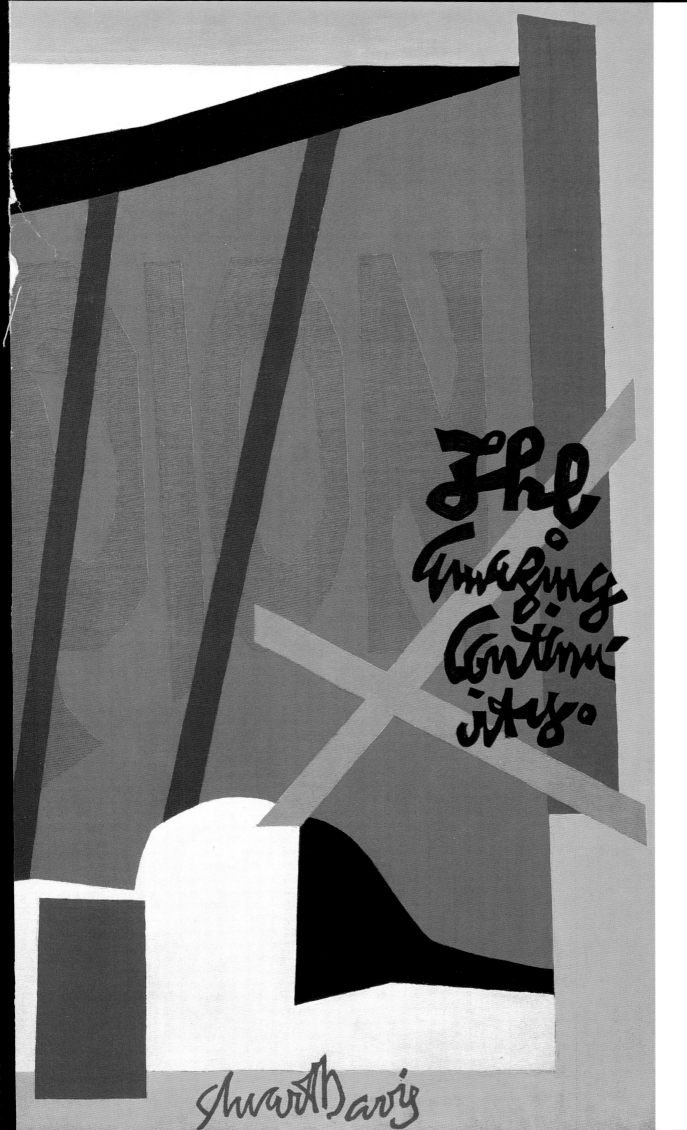

Visa

STUART DAVIS, 1951;
oil on canvas; 40 x 52 in.
(101.6 x 132.1 cm).
Gift of Mrs. Gertrud
A. Mellon, The Museum
of Modern Art, New York.
© 1997 Estate of Stuart
Davis/Licensed by VAGA,
New York, N.Y.

Davis consistently
worked, in the first
half of the century,
through European
modernist art from
an American per-
spective. He used
Cubism and abstrac-
tion as lenses to focus
and portray the brash
colors, simplified
shapes, and sounds
of the American
experience. He legit-
imized what was
to become a large
part of the subject
matter for Pop art.

Abstract Expressionism

The more thorough, pervasive revolution came at the hands of the Abstract Expressionists in the 1940s and '50s, within an art form that seems visually and conceptually to be a rejection of everything so far outlined. It is abstract, rejects the local realism argued by the American regionalists of the 1930 and '40s, and apparently has nothing to do with popular culture.

This, many argue, is the Abstract Expressionism that existed and stood in opposition to the coming of Pop art. And a case may indeed be made for this reading of the large-scale, heroic canvases which accepted then altered the major European modernist traditions of abstract art—Cubism, Expressionism, and Surrealism—into their own vision of modernism, American-style. Yet it is just this sense of the development of a unique Americanism that relates them simultaneously to the American past and future.

Artists such as Jackson Pollock, Willem de Kooning, Clyfford Still, and Mark Rothko argued against the provincialism of a strictly backyard American approach to art because they realized that to be "great" meant accepting the challenges provided by European modernism. They would be great by being international rather than through a nationalist parochialism. But in the process they also consciously replaced European motifs, such as Greek and Roman mythology, with that of native American concepts, or took ideas from a sense of local nature found in the quiet of Long Island or the rugged mountain and desert vistas of the western United States. The great European universalism was mediated by the local American specifics, much the same way the American modernists had operated throughout the century.

Nor was there a total turning away from popular culture for something higher in status or more mystical. The "primitive" smile of Willem de Kooning's celebrated *Woman* series initially derived from a set of lips cut from a magazine ad for cigarettes and collaged directly into a painting—a far more direct and startling conjunction of Cubism and popular culture than Stuart Davis had attempted thirty years earlier.

It is perhaps not surprising that many members of the so-called second generation of American Abstract Expressionists, working in the 1950s and '60s, such as Grace Hartigan,

Woman I

WILLEM DE KOONING, 1950–52; oil on canvas; 6 ft. 7⅞ in. x 58 in.

(192.7 x 147.3 cm). Purchase, The Museum of Modern Art, New York. © 1997

Willem de Kooning Revocable Trust/Artists Rights Society (ARS), New York.

Dutchman de Kooning's lifelong exploration of both the figure and abstraction convinced many American painters that there was artistic territory left to explore. Viewers could "read" his female icons as ever in process, never cloaked in a sense of finish or singular identity. In a word, de Kooning kept the figure alive.

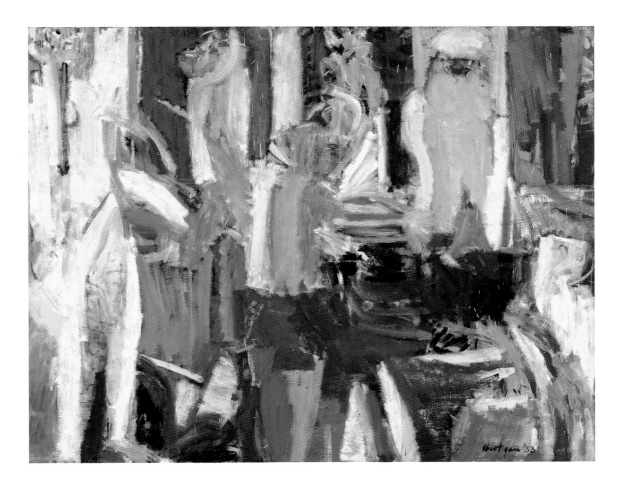

River Bathers

GRACE HARTIGAN, 1953; oil on canvas; 69³⁄₈ x 7 ft. 4³⁄₄ in. (176.2 x 225.5 cm). Given anonymously, The Museum of Modern Art, New York. Hartigan was the most direct among the second-generation Abstract Expressionists in the continuation of de Kooning's struggle with abstraction and figuration. What relates Hartigan to Pop art, aside from preserving the figure, is her focus on the narratives of day-to-day life in New York's Lower East Side.

turned their concentration to the combination of abstraction and expressionism with figures drawn from their experience of the streets of New York. Like their European counterparts, although distinct in tone and meaning, the conjunction of figure, expression, and abstract modernism served to modify the idea of realism. The new reality of a human figure shifted toward something more like that of a cipher, where the style testified as much to the realism of being human as did the use of the human form in her search for what was "vulgar and vital in American life."

American and European artists in the 1960s received the human figure transfigured and transvalued from their predecessors. In the United States the line between abstract figures emerging from the influence of Abstract Expressionism and those figures used in much of Pop art would be visually different but conceptually impossible to separate.

The Neo-Dada Aesthetic

The Abstract Expressionists were seen in their time as the response of the alienated outsider to the conformity and materialism of the postwar American society characterized by the image of the newly modeled men in gray flannel suits. But the Abstract Expressionists were also a culture of older males, looking across the ocean and backward in art history, not unlike many of Europe's early modern masters.

The image of James Dean in the 1955 movie *Rebel Without a Cause* may have borne some general relationship to the projected image of Jackson Pollock, the anguished nonconformist, but Dean was in his mid-twenties while Pollock was then forty-three. Pollock had advertised himself as the cowboy from Wyoming, with work boots and pickup truck, while the actor projected a figure of both the urban and the youth cultures emerging from the materialist 1950s.

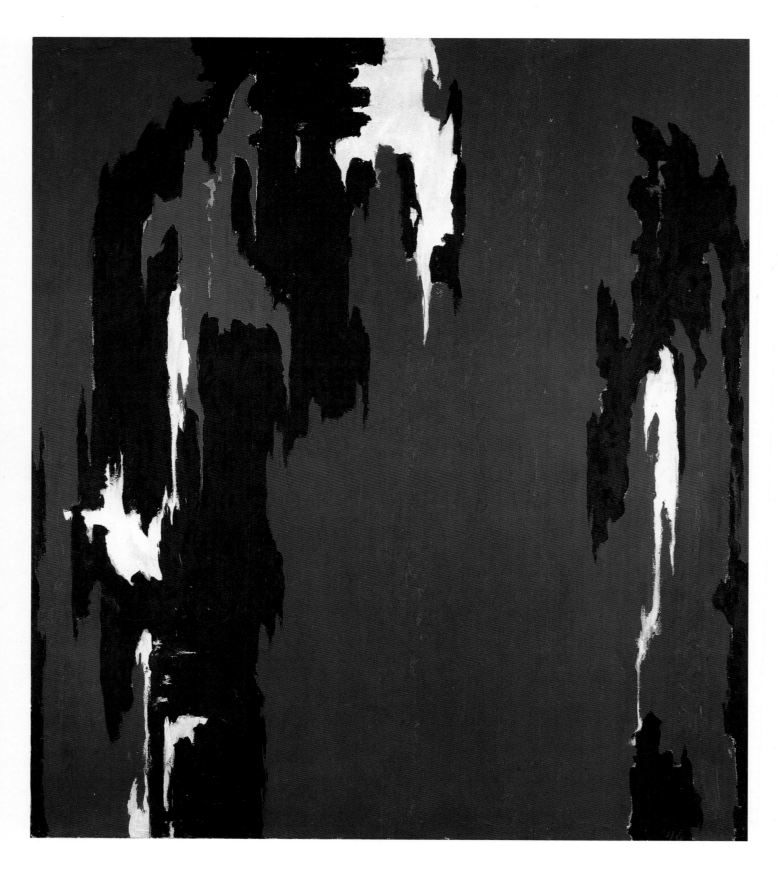

In the same year as *Rebel* the American poet Allen Ginsberg wrote a new anthem he titled "Howl." It was a poem whose screams against material and spiritual conformity may have been influenced by the struggles of the New York school of artists but it was one whose cadence signaled a new wave not unlike the earlier cabaret drums of the European Dadaists beating against the dehumanization of World War I.

The characteristics of this youth or Beat subculture, an avant-garde within the avant-garde, were radically different from their older predecessors. In the arts it was defined by the combination of Duchamp, who was still living in New York City at the time, and the ideas of John Cage in musicology, Merce Cunningham in modern dance choreography, and the two visual artists Robert Rauschenberg and Jasper Johns. Taken together the attitude-turned-movement was labeled neo-Dada; the art historian Irving Sandler characterized it, more specifically, as the "Cage-Duchamp aesthetic." Both terms celebrate the conjunction of earlier ideas, Dadaism and Duchamp, seen through the new particulars of a postwar world moment.

John Cage

By the late 1930s John Cage was established among avant-garde composers in New York. Like his teacher, the composer Arnold Schoenberg, Cage had developed a sense of withdrawal from the construction of traditional forms of melody and harmony. Schoenberg

1946-H (Indian Red and Black)

CLYFFORD STILL, *1946; oil on canvas; 78¼ x 68⅜ in. (198.7 x 173.6 cm). National Museum of American Art, Smithsonian Institution, Washington, D.C.*

Still, along with Mark Rothko and Barnett Newman, were among the so-called field painters of the Abstract Expressionists, and while their gestural qualities were apparently rejected by the Pop artists, the concept they offered of painting as a unified "field" of tensions lived on in artists such as Lichtenstein and Warhol.

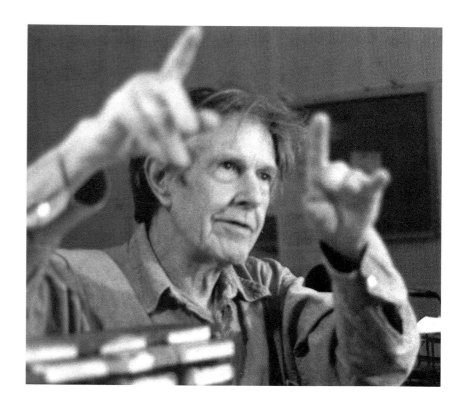

had revolutionized modern musical composition by refusing to enforce tonal direction onto his arrangements. Similarly, Cage had developed what he called a "prepared piano," whose disharmonies could not be predicted, and began using audio fragments on tape. His refusals were reinforced in the 1940s by the combination of his friendships and collaborations with Duchamp and Cunningham and a devotion to the discipline of Zen Buddhism.

Cage began to accept the role of chance in creation but not as the Surrealists had applied it. Chance was not an attempt to contact the artist's unconscious but rather to accept the ways of the world around the viewer or "artist." As Cage himself noted, he was quite happy with existence but people had to notice and accept it for its own sake rather than impose themselves upon it.

By the 1950s Cage threw coins or yarrow stalks and accepted their corresponding arrangements in the Chinese *I Ching*, or Book of Changes, as an objective way to assign qualities to his notes. His work also accepted

John Cage

Photograph dated July 27, 1987. Andrew Hill/ Corbis-Bettmann.

Few artists, let alone musicians, were as influential in the development of the visual arts after 1950 as John Cage. His arguments for the withdrawal of the artistic ego on behalf of the audience, for the operations of chance, and for the integrity of the surrounding physical world reinforced the message of Marcel Duchamp on several generations of artists.

**First Landing
Jump**

*ROBERT RAUSCHENBERG,
1961; combine painting:
cloth, metal, leather, electric
fixture, cable, and oil paint
on composition board; overall,
including automobile tire
and wooden plank on floor;
7 ft. 5⅛ in. x 6 ft. x 8⅞ in.
(226.3 x 182.8 x 22.5 cm).
Gift of Philip Johnson,
The Museum of Modern Art,
New York. © 1997 Robert
Rauschenberg/Licensed by
VAGA, New York, N.Y.*
The development
of what were called
"combine paintings"
by Rauschenberg was
a continuation of his
"junk aesthetic," which
accepted the world on
its own terms, much
the way John Cage
accepted environ-
mental noise or silence
as music. The Pop
artists saw the point.

the ambient sounds and especially the silences of the world as integral components to his understanding of "music." In so doing, he greatly expanded the range of modern music and composition and erased many of the traditional lines imposed between art and life. In this he continued the project initiated by Duchamp. He also served as teacher and inspiration to a number of New York artists.

Merce Cunningham

Similarly, Merce Cunningham, who began collaborations with Cage in the early 1940s while still a dancer with Martha Graham's company, expanded the basic repertoire of modern dance by accepting the random movements of his dancers as "dance." Their model was the daily collisions of sound, sight, and movement in the world.

Cunningham and Cage refused to allow music and dance to fuse as one system by approaching each as a separate domain and allowing them to coexist with their own integrity rather than in synthesis. Each dancer, like each note, was allowed an equality within a non-hierarchical assemblage that accepted the Dada concept of simultaneity rather than the imposition of linear narrative or climactic arrangement. As Cage expanded the base for music, so too did Cunningham for modern dance—any noise and any movement could be now be accepted as part of the performance.

Robert Rauschenberg

Like Cage and Cunningham, Robert Rauschenberg was, in the beginning, attempting to work with some of the same ideas in the visual arts. He collaborated with Cage in the late 1940s and early '50s and later with the Merce Cunningham Dance Company. Rauschenberg allowed his world to constitute the elements of his art. By 1951 he "accepted" what he called "combine" paintings, which

became an assemblage of a wide range of objects he had found in the world.

The elements of the world, begun in a Duchampian sense, took on greater complexity though not so much through artistic transformation as by accretion. Summarily, the components of art became like those of the new "music" and the new "dance"; individual elements, none to the exclusion of others, were distributed in a non-hierarchical field that re-emersed the viewer into the world rather than shunted him or her away from it and into a sacred and separate precinct labeled *art*. As Rauschenberg himself has stated: "I try to act in that gap between the two (i.e., art and life)."

Images were utilized in the combine paintings but as found objects located in the world rather than merely created. The random brushstrokes of color used consistently throughout these works are a reference to the gesturalism of Abstract Expressionism, but contrary to their aesthetic Rauschenberg never allowed style or gestures to dominate or falsely integrate the other elements.

By the 1960s he turned his attention to printmaking, especially silk-screen processes, and large paintings—often in combination—that brought images in abundance from postcards and magazines as well as from the worlds of news, science, and art. His works were constructed from pre-existing images and retained the chaotic sense of visual bombardment of daily life. They seem less about some single thing than part of the continuum of abundance, repetition, and disjunction of daily existence in a newly image-saturated culture.

Herein is the culture, if not all the ideas, of Pop art, a world Canadian sociologist Marshall McLuhan described in his 1964 book *Understanding Media* as dominated by the dissemination of reproductions. According to McLuhan's famous dictum, the medium itself constituted the message or content.

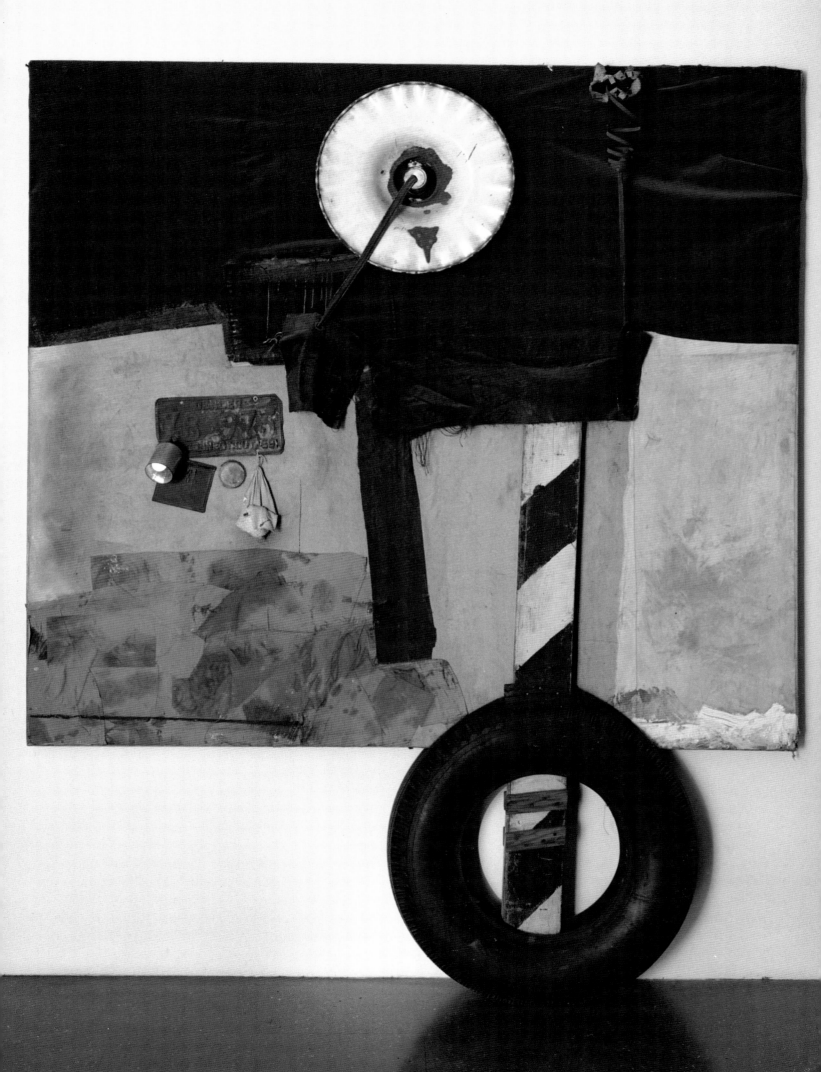

**Canto XXI:
Circle Eight,
Bolgia 5,
The Grafters**

*Robert Rauschenberg,
from the series "Thirty-four
illustrations for Dante's
Inferno," 1959–60; transfer
drawing, gouache, cut and
pasted paper, pencil, colored
pencil, wash on paper; 14³/₈ x
11¹/₂ in. (36.5 x 29.2 cm).
Given anonymously,
The Museum of Modern Art,
New York. © 1997 Robert
Rauschenberg/Licensed by
VAGA, New York, N.Y.*
Late in the 1950s
Rauschenberg turned
to what would become
his dominant mode of
"picturing" in the 1960s
in his suite of drawings
to illustrate Dante's
Inferno. The chemical
soaking of images found
in the world transferred
to the canvas was the
perfect solution for
someone who wanted to
remain concrete while
letting the materials
suggest the technique.

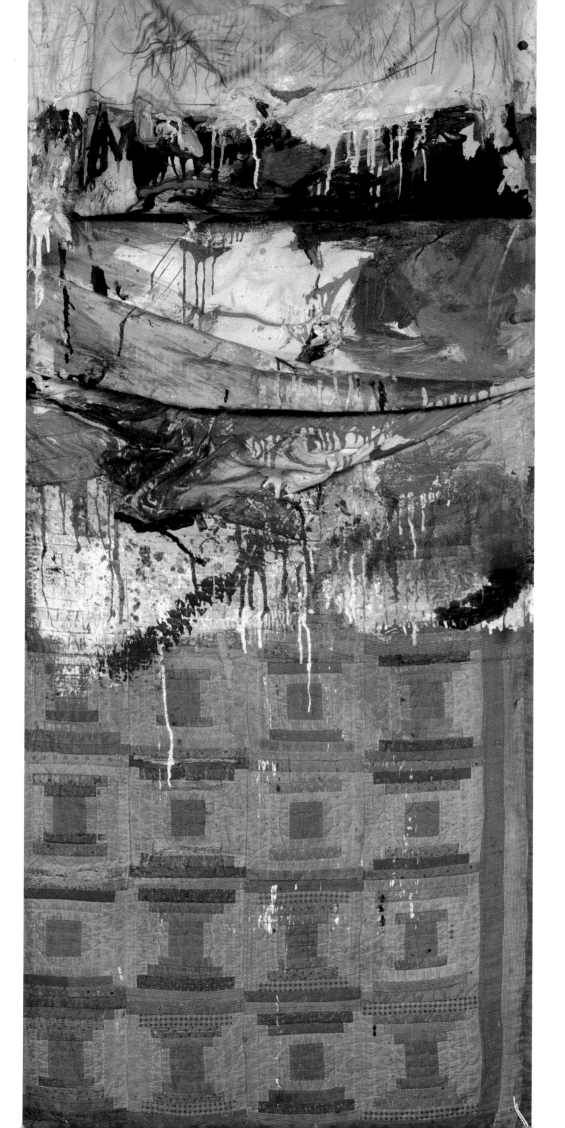

Bed

*ROBERT RAUSCHENBERG, 1955;
combine painting: oil and pencil
on pillow, quilt, and sheet on wood
supports; 6 ft. 3¼ in. x 31½ in. x 8 in.
(191.1 x 80 x 20.3 cm). Gift of
Leo Castelli in honor of Alfred
Barr, Jr., The Museum of Modern
Art, New York. © 1997 Robert
Rauschenberg/Licensed by
VAGA, New York, N.Y.*
Rauschenberg's use of ob-
jects found in the world
and his relative withdrawal
from exerting his will to
reshape them was seen as
a rejection of the Abstract
Expressionist model for
the meaning of art and
creation. The Pop artists
would come to accept his
model rather than a more
emotionally expressive one.

According to What

JASPER JOHNS, 1964; oil on canvas; 7 ft. 4 in. x 16 in. (223.5 x 40. 6 cm). Collection of Edwin Janss, Thousand Oaks, California. © 1997 Jasper Johns/Licensed by VAGA, New York, N.Y.

Few of Johns's paintings pose so clearly the fundamental issue in his work: What are the rules for meaning? Often they result from the use of codes within systems and many of the references here are to the "system" of painting—Abstract Expressionism—with its codes of gestural brushstrokes and use of red, yellow, and blue.

Jasper Johns

Success came much faster to Rauschenberg's friend and colleague Jasper Johns, who was motivated by similar concepts but attached himself more programmatically to the issue of systems.

Johns purposefully selected flat, but meaningful images such as targets, flags, and maps, repainting them on canvases in textured surfaces of colored wax (encaustic). The flatness was a reference to the affinity of many Abstract Expressionist painters for the flat surfaces of modern abstract paintings, and in a perverse way, the waxy quality of John's surfaces also referenced the gestural qualities of the expressionists. But any sense of expression is always countermanded by Johns, frozen somewhere, and made into a reference or "sign" about its own existence. Like Duchamp, his was always a wry tongue-in-cheek attitude.

Johns worked in series rather than toward individual works, and selected as his starting point known images or systems used in the world that help classify, clarify, and direct—maps, numbers in sequence, measuring

devices—which all became agents of misdirection. The clarity of the maps and numbers—the direction givers—is obliterated, but not until the viewer has been given enough information to identify the broad nature of the issues. As the title to one of his pieces cogently questions, Johns himself is asking "According to What" are the rules?

Johns' works seem to be a language about the very systems of "sense" we use, and the real possibility of their erasure, alteration, or misconception. Ultimately there is a cool sense of measuring the very devices of measuring. In the revived Dada tradition these are not merely non-sense but an attempt to question the ways in which we make sense of and in the world.

In many ways the issues in Pop art follow from those of Rauschenberg and Johns, yet they also remain different. Both have made it clear they do not consider themselves Pop artists, despite the world's constant attempt to place them within the movement. And they are correct. American Pop art owes much to these two artists but is much less inclusive in its concerns.

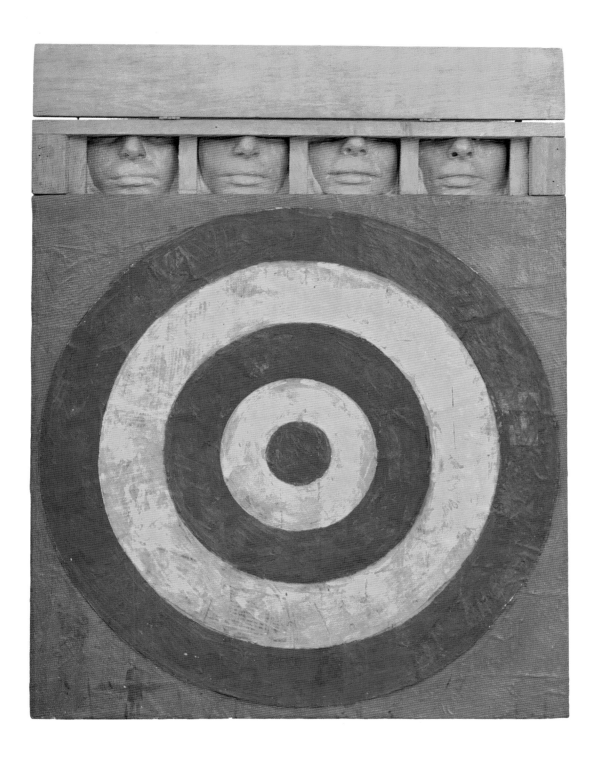

Target with Four Faces

JASPER JOHNS, 1955; encaustic and collage on canvas with objects; 26 x 26 in. (66 x 66 cm) surmounted by four tinted plaster faces in wood box with hinged front. Gift of Mr. and Mrs. Robert C. Scull, The Museum of Modern Art, New York. © 1997 Jasper Johns/Licensed by VAGA, New York, N.Y.

Johns remarked that he chose objects easily recognized to allow him to play on other levels of meaning. Here the different systems of painting and sculpture assemble to reference and defy definitions of art that had separated the two and declared painting a form concerned only with the flatness of the surface.

POP ART

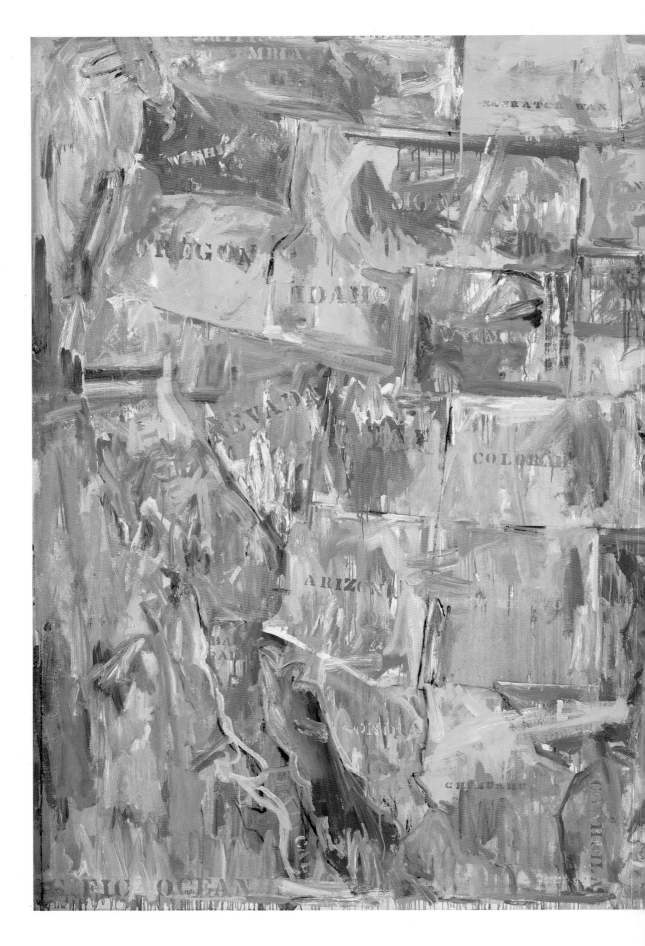

Map

In the 1960s Johns's
sense of irony was
consumed with rules
and conventions
accepted by society to
communicate meaning.
He purposefully
selected maps, num-
bering systems, and
mechanical measuring
devices that gave
order to the world,
and then obliterated or
confused their percep-
tual clarity against their
conceptual function.

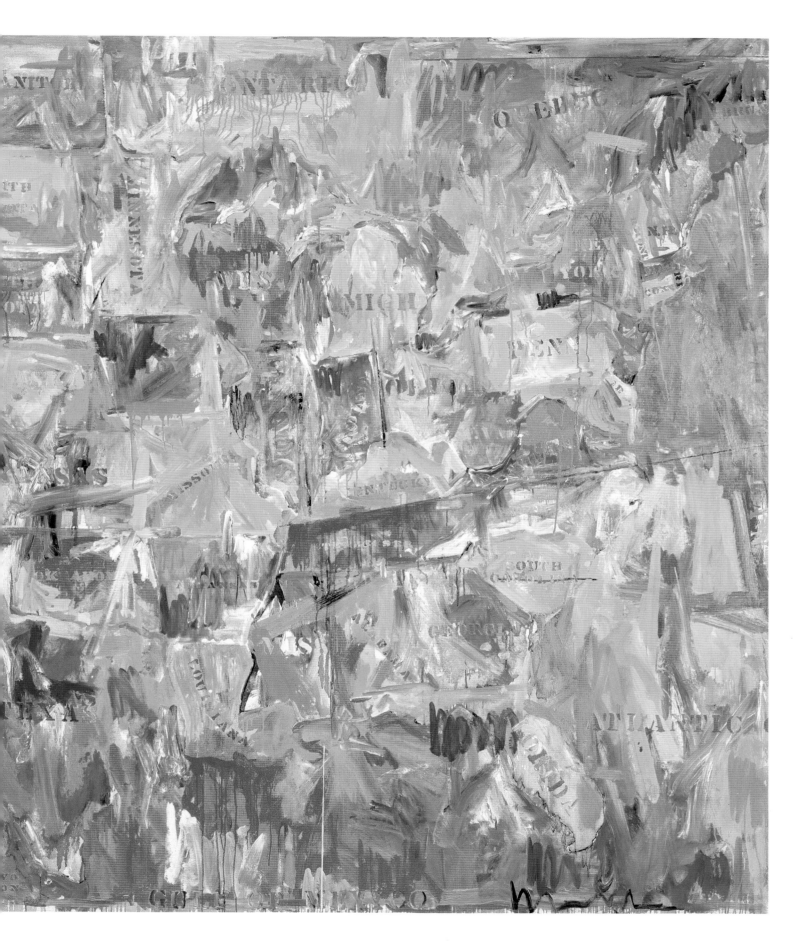

POP ART IN THE UNITED STATES

Pop art was not an art movement in the sense of a distinctly defined and collective group. There were no organizations or meetings, no manifestoes or unitary calls for a particular orientation toward art, not even a focused group of friends who met regularly to exchange conversation and drinks, as was the case with the Abstract Expressionists.

There were a series of individuals working independently, many of whom eventually knew about the others, with several centers within New York—frequently their studios became their sites—and a series of artistic events that can best be described as "conceptual performances" attended by a shifting amalgam of artists and friends. No one knew of a so-called movement and there seemed to be little concern for enforcing a sense of order onto what appeared to be simply a group of people reacting diversely toward the nature of a culture that was itself in the midst of change. Yet both assumptions—the reshaping of a culture and the close connection of art to life—were

new, radical, and important, with long-term consequences.

Among the many interpretations of Pop art there is common agreement that it somehow developed out of the dramatic upheavals within the cultures of organized Western societies during the 1960s. In the United States, events of social unrest and redefinition are frequently cited: the civil rights movement; the protests against the Vietnam War; the formation of an active counterculture based on youth and idealism; the developing consciousness of the feminist movement. However, not only did Pop art begin prior to most of these developments, there were numerous aspects of the counterculture that opposed the very world of technology and advertising that American Pop art referenced. At the same time and in contradiction, much of the counterculture cherished Pop at a time when most art critics rejected it.

No doubt the critical qualities inherent in most of these movements of social conscience paved the way for the fairly quick acceptance of Pop art, which proved "popular" by the mid- to late 1960s; even the back-to-the-earth or green revolution accepted Pop, interpreting it as a stinging or humorous indictment rather than an acceptance of corporate America. And therein lay the strength of Pop art: its ability to cut across an audience in opposing directions. For critics, especially liberals and leftists, Pop art was then, as it often remains interpreted, a co-option by the forces of capitalism invested in the pervasive phenomenon of media. Critics

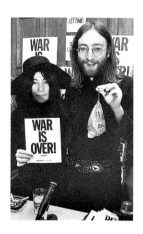

John Lennon and Yoko Ono— "War is Over– If You Want It"

Montreal; photograph dated December 22, 1969. UPI/Corbis-Bettmann.

John Lennon and Yoko Ono were active in the sixties peace movement, and as conceptual artists they shared a vision. Ono emerged from New York events and performances, which formed the basis for much of Pop art, then developed into Fluxus. Here their "bag" emits laughter from the tiny recorder inside.

Trowel

CLAES OLDENBURG, c. 1972.

Kröller-Müller Museum, the Netherlands.

In the 1970s Oldenburg was able to realize the monumental projects that had existed only on paper in the mid-1960s. Consequently, a series of everyday objects have been placed and embedded across the Western world, making playthings into sculpture and serving to remind us that play is at the center of art.

felt that art, especially advanced or avant-garde art, should offer resistance and a critique of the system which spawned it. Pop art, instead, appeared to present nothing but thoughtless play offered up by a "moronic" consciousness, as one commentator identified it.

Conversely, counterculturists recognized play for mockery. In a system that seemed to dispense with the value of individuals, laughter was both the least expensive and most expansive weapon for people who decided to march or sit-down in peaceful protest. What could be more perfect than Roy Lichtenstein supposedly "celebrating" war by utilizing altered panels from war comic books in his work. The children were laughing at the adults using children's toys as weapons. To everyone's surprise, the tactic worked on a social level, but only eventually, partially, and much later.

American art critics had championed American Abstract Expressionism to the world, as the nation rose in power after the Second World War in tandem with the development of the abstract art they defended. But Pop art went to acceptance, especially by the marketplace, without the general consent of the critics, thereby eventually dissipating their power to the arena of support and market. Gallery dealers, collectors, and curators took on a greater influence than critics in the art network, a fact that remains so today. Indeed, it was the artists and their images, within a culture that was learning to embrace the visual, that became the apparatus of criticism.

Pop art was a criticism and a celebration of art and its modernist rules in the same way that it criticized and celebrated the very culture that had generated the changes. It was possible to

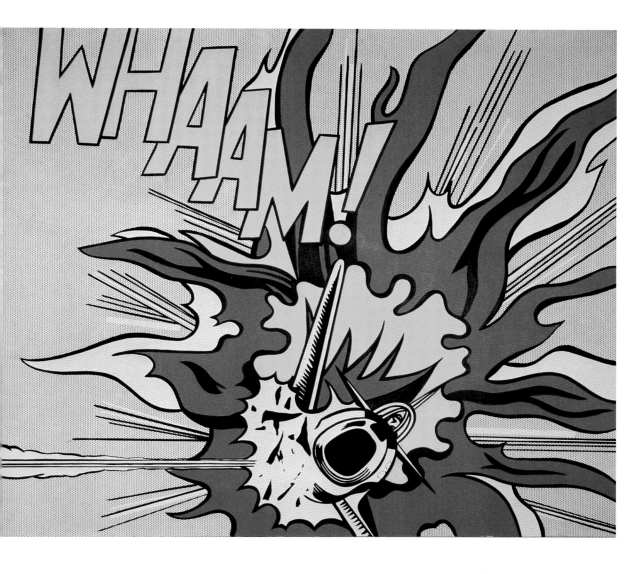

Whaam!
ROY LICHTENSTEIN;
magna on canvas, two panels;
5 ft. 8 in. x 13 ft. 4 in.
(172.7 x 406. 4 cm).
The Tate Gallery, London.
© Roy Lichtenstein.
Despite years of rhetoric to the contrary, Lichtenstein did not simply replicate projected images from comics; he altered them into abstract patterns that collapsed forms and space into something more "modernist." The cool irony comes in deflating the heat of battle action.

have your pop and drink it, too; a cultural condition of either/or situational choices had become, for the first time and in an open manner, a condition of and/also. But what precisely was this culture it celebrated and critiqued; what was the location of *pop*?

Lawrence Alloway, the "Pop" of Pop

Lawrence Alloway, the English-born art critic who coined the word Pop, applied it originally to developments in England in the 1950s and later extended it to Rauschenberg's early combine works and the performance and installation works of the American artists from 1959 to 1961. "Popular" in this case meant the acceptance by those artists of an anthropological orientation, assigning and accepting the general range of artifacts of human culture as the grounds for art. Only later, from 1961 to

1964, did Pop art evolve into what most accept today: an art that drew directly from sources in the commercial mass-media, or, perhaps more accurately, from sources in the new phenomenon of "media culture."

For Alloway, the realm of the New York Pop artist was visual art whose primary source was the media, and the media was a different, more restricted source of subject matter and concern than envisioned when he first used the term in England. Ultimately, Alloway argued that if the restrictive understanding remained the definition of "Pop Art," as it did in New York, then another word was needed for "the wider field of general culture," for which Alloway proposed "Pop Culture."

Thus Alloway described two different though related histories. The variations on the wider understanding of the term remained operative

41

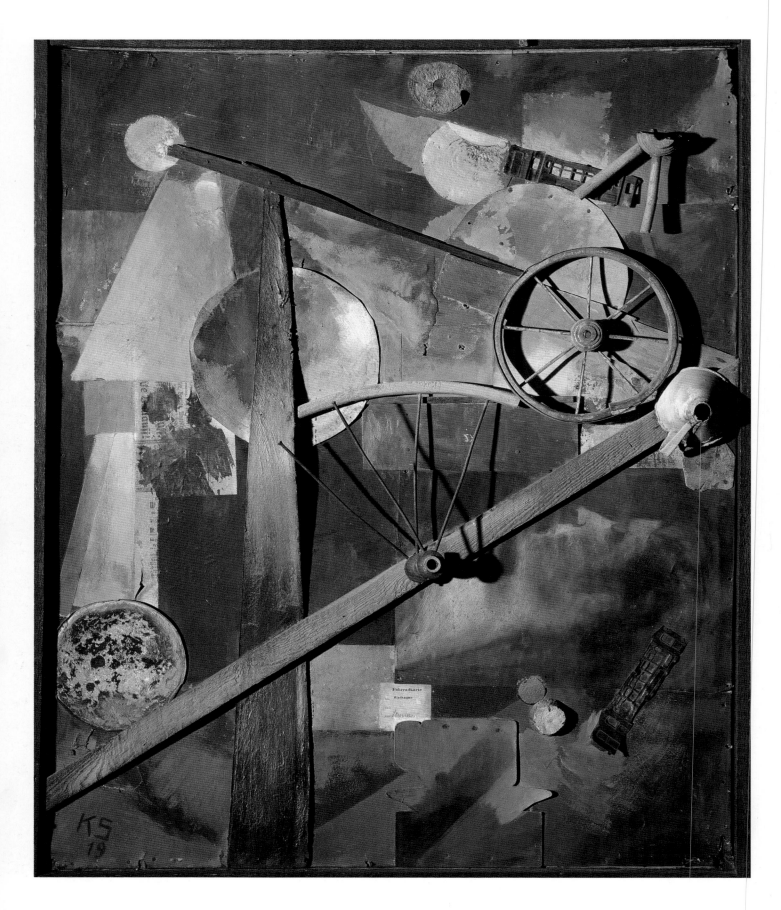

in the New York area until about 1961, but were consistently embraced in the Midwest and West Coast of the United States and in Europe; the more limited use became known as New York Pop art, thereby lumping a set of very thick and complex types of art under the simplified, singular umbrella of Pop. This chapter outlines both the more restrictive sense of New York Pop, often considered the mainstream, and the more diverse variations in New York, California, and Chicago; the third chapter takes up the complexities in Europe.

The Junk & Constructive Aesthetic

Alloway's system of historical phases is useful in describing the New York scene since the use of objects, performances, and installations marked the early development of Pop art, followed by a more specific and confined set of concerns after 1962. The two phases are related but also quite distinct, with the breadth and rawness of the earlier aspects closer to the attitude that remained in Chicago, parts of the West Coast, and Europe.

New York sculptors had accepted "junk" as a natural extension of Duchamp's Dadaist found objects and Dubuffet's acceptance of the realm of the impure as the logical postwar source for art forms.

Rauschenberg's early '50s combine paintings were the most recent variation of this aesthetic developed from early Dadaist "konstructions" like those created by German artist Kurt Schwitters. In New York sculptors turned more

Konstruction für edle Frauen

KURT SCHWITTERS, 1919; relief assembly, wood, metal, colors. Los Angeles County Museum. © 1997 Artists Rights Society (ARS), New York/VG Bild-Kunst, Bonn.
Schwitters's assertion that he was a painter who nailed his paintings together was accepted in the grand, new illogic of the Dada movement. His were "constructions" both from found objects, usually junk, and his own sensibility, effectively creating a surprisingly easy step between 1919 and the 1950s.

Opened By Customs

KURT SCHWITTERS, 1937–38; collage. The Tate Gallery, London. © 1997 Artists Rights Society (ARS), New York/VG Bild-Kunst, Bonn.
Schwitters had the eventual distinction of being thrown out of the European Dada movement for being too programmatic. Yet he continued to use scraps and bits of everyday materials in his more structured collages, many of which were exhibited consistently in New York during the 1950s.

directly to discards, with John Stankiewiez welding pieces of scrap machine and boiler parts and Richard Chamberlain welding parts of junkyard cars. This new form of construction—the welding of urban discards into a new realism—was widely practiced in both the United States and Europe.

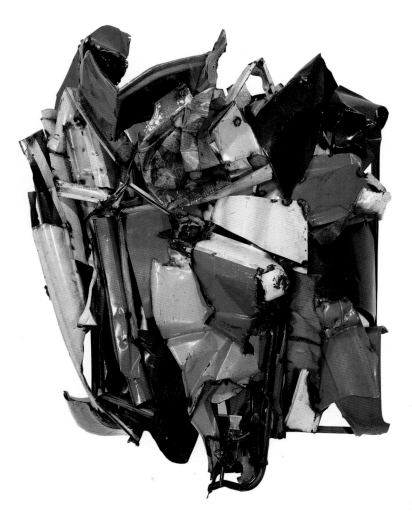

Essex

RICHARD CHAMBERLAIN, 1960; automobile body parts and other metal, relief; 9 ft. x 6 ft. 8 in. x 43 in. (274.3 x 203.2 x 109.2 cm). Gift of Mr. and Mrs. Robert C. Scull and purchase, The Museum of Modern Art, New York.
Chamberlain and César—simultaneously and independently in the United States and Europe—turned for their "found object" to the most powerful and plentiful icon of the twentieth century: the automobile. Unlike César, however, Chamberlain would find and explore a Baroque sense of beauty in his assemblages.

Dubuffet in Paris coined the term *assemblage* at about this time to designate works that assembled elements from the real world, thus erasing many of the distinctions between painting and sculpture in favor of the simpler idea of arranging parts. Critics on both sides of the Atlantic wrote in retrospect of the "death of painting" and sculpture in the face of objects and concepts that seemed to deny more conventional ideas of creativity and beauty in art. Both Eduardo Paolozzi in London and Stankiewiez in New York spoke of the naturalness of such items within a post-nuclear world—a kind of urban-outfitters primitivism. Thus when Pop artists turned to the streets and its discarded refuse they were part of a larger picture, but it was one they in their turn would enlarge.

The Performative—
from Actions to Concepts

The concept of "performance" had been an integral part of European avant-garde art since the turn of the century. The Italian Futurists staged absurd, dizzying stage events designed to destroy conventional understandings of theater and to shock the middle class out of the past. Such events passed into the hands of the Dadaists, for whom the cabaret performance became a kind of laboratory to explore the effect of multi-media events which put forth music or brutal sound, dance, non-sense "poetry," randomness, and designer madness as the politics of cultural if not always political revolution.

The Surrealists continued the process but in tamer versions, since they wanted to implement a systematic and sustained sense of revolutionary consciousness. The record of the Dada events, published in the United States in English in 1951, dovetailed with the "events" staged by John Cage in the late 1940s and early '50s, and this led several artists toward their own acceptance of art as a type of action in the day-to-day world.

Allan Kaprow had read of the Dada events and studied with John Cage in New York City. But in what is one of the most intriguing

conjunctions in the history of modern art, Kaprow wrote that it was the gestural dance by painter Jackson Pollock that most influenced his development of a series of events he came to call "Happenings." For Kaprow, originally an abstract expressionist painter himself, as for many other interpreters, it was the implication of Pollock's process far more than his actual paintings that inspired him. Pollock's physical gestures of creation brought a spontaneous directness to the fore, such that creation was not only the issue but creation within the local

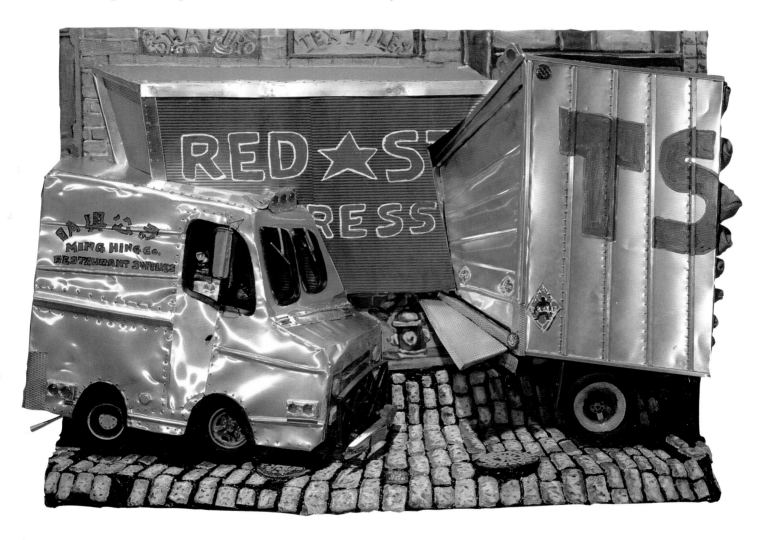

Red Star

RED GROOMS, 1980; painted aluminum and ceramic relief with rubber, fabric, wood, plastic, tar, and synthetic polymer paint on canvas; 35⅛ x 51⅛ x 11 in. (89.1 x 129.7 x 27.9 cm). Acquired through the William A. M. Burden and Mr. and Mrs. Samuel C. Dretzin Funds and purchase, The Museum of Modern Art, New York. © 1997 Red Grooms/Artists Rights Society (ARS), New York.

Grooms converted a sense of the liveliness of his earlier Happenings into theatrical installations he called "sculpto-picto-ramas" in testimony to their hybrid character. Large enough to walk through, small enough to hold, Grooms's works use slapstick funk to offer witty snapshots of our human foibles and environments.

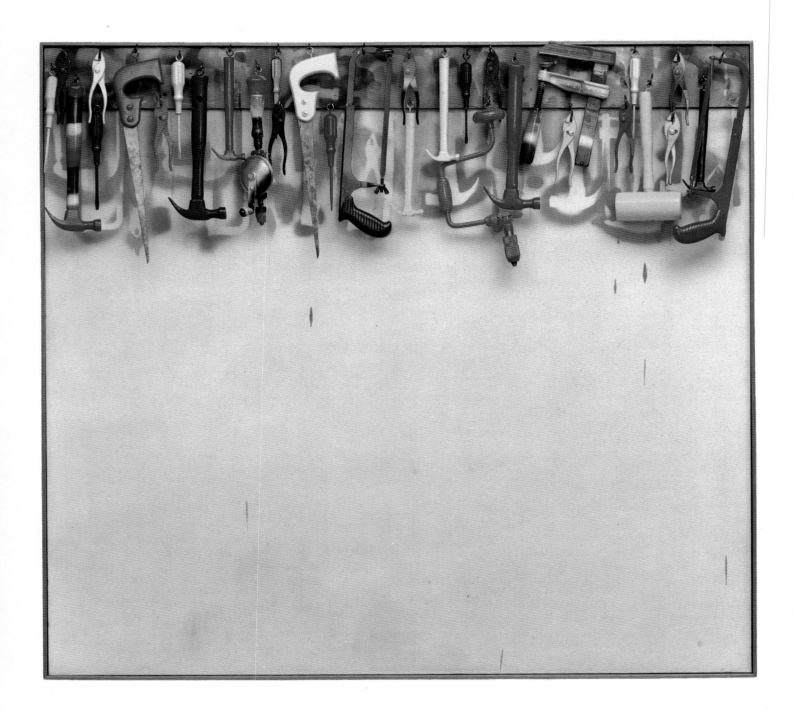

Five Feet of Colorful Tools

JIM DINE, 1962; oil on unprimed canvas with mounted wooden strip and thirty-two tools hung from hooks; 55⅝ x 60¼ x 4⅜ in. (141.2 x 152.9 x 11 cm).
The Sidney and Harriet Janis Collection, The Museum of Modern Art, New York.
Dine's incorporation of tools into his paintings originated from his work in his grandfather's hardware store, and his emphasis was on making obvious the nature of art as construction. The painting and stenciling of their outlines posed questions about the relation between the real and painted object.

confines of the space around the artist. For Pollock the confine was the studio and European art theory; for Kaprow and other soon-to-be Pop artists under the influence of Rauschenberg and Cage, the realm was the world at large and, particularly, New York City's singular urban culture.

Happenings provided a general script, props, some instructions, and even rehearsals, but also built into them was a purposeful unpredictability and simultaneity that embodied the directness of experience and less than linear processes that were its European heritage. The emphasis was on actions that purposefully involved elements taken from the everyday world while utilizing audience members as integral elements. Countless events and variations were staged, from 1958 well into the 1960s, by Kaprow, George Segal, Red Grooms, Claes and Pat Oldenburg, Jim Dine, Lucas Samaras, et al—many centered at or by artists of the Reuben Gallery—and an ever changing cast of nonprofessional friends.

Despite their brief life span the context of Happenings demonstrated to a number of artists a set of ideas that could be marshaled into other arenas: performance art emerged from among these activities, conjoined with the new experiences and definitions in modern dance and music. Many of the artists, including the Pop artists, turned equally to photography, film, and video, making far less distinctions

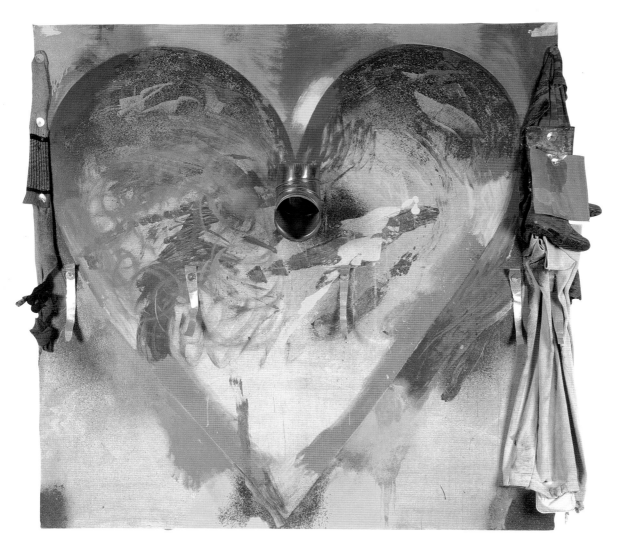

Putney Winter Heart

JIM DINE, 1971–72. Musée National d'Art Moderne, Paris.

Dine always denied a direct relation to Pop art, considering it cool and exterior while his art was derived from autobiographical sources and functioned "as a vocabulary of feelings."

The Family

*MARISOL (Marisol Escobar),
1962; painted wood and other
materials in three sections;
6 ft. 10⁵/₈ in. x 65¹/₂ x 15¹/₂ in.
(209.8 x 166.3 x 39.3 cm).
Advisory Committee Fund,
The Museum of Modern
Art, New York.
© 1997 Marisol Escobar
Licensed by VAGA,
New York.*
Marisol's environments
are of life-sized figures
cut from blocky wooden
body forms while inter-
spersed casts, drawings,
and photographs are used
for faces and limbs. The
mixing of media is not
illusion but a recognition
of media as elements
of interchangeability.

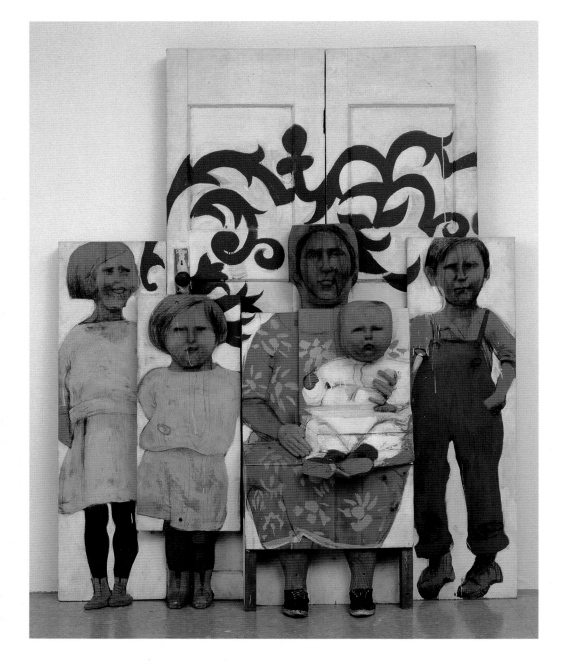

between these media. A number of artists, such as Samaras, Segal, and Marisol Escobar, went on to use and make objects, disclaiming them- selves as sculptors while emphasizing psycho- logical and sociological issues generally avoided in the history of "modernist" sculpture.

The great irony is that center stage to this wide ranging celebration of frenetic expression and the object was the realization that the site of art was in activity or process and, ultimately, in the mind. Even Fluxus, the loosely defined

The Bus Driver

GEORGE SEGAL, 1962; figure of plaster over cheesecloth; bus parts including coin box, steering wheel, driver's seat, railing, dashboard, etc.; figure: 53¹/₂ x 26⁷/₈ x 45 in. (136 x 68.2 x 114 cm); overall, 7 ft. 5 in. x 51⁵/₈ in. x 6 ft. 4⁴/₅ in. (226 x 131 x 195 cm). Philip Johnson Fund, The Museum of Modern Art, New York. © 1997 George Segal/Licensed by VAGA, New York, N.Y.
Transforming his paintings into "real-life" environ- ments, Segal created what one critic called "quick- frozen Happenings." But the eerie quality of iso- lation inherent in his white plaster figures speaks to psycho-social conditions inherent in everyday moments.

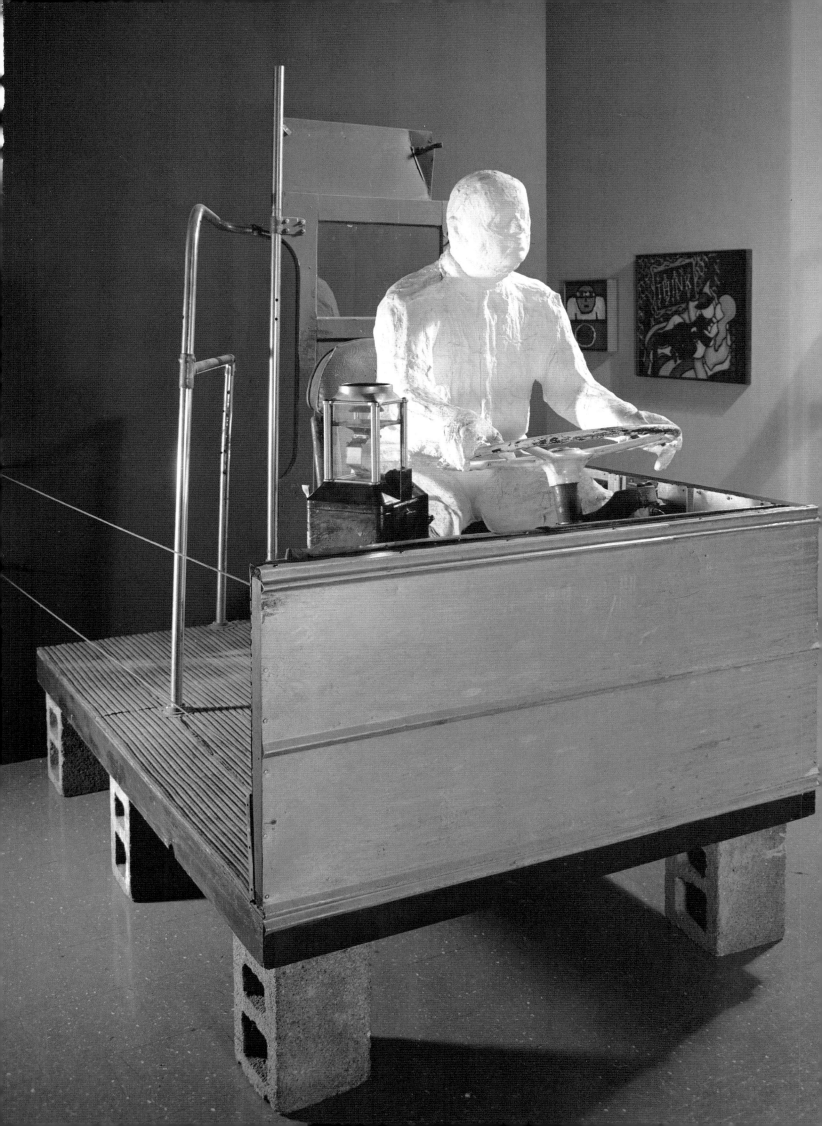

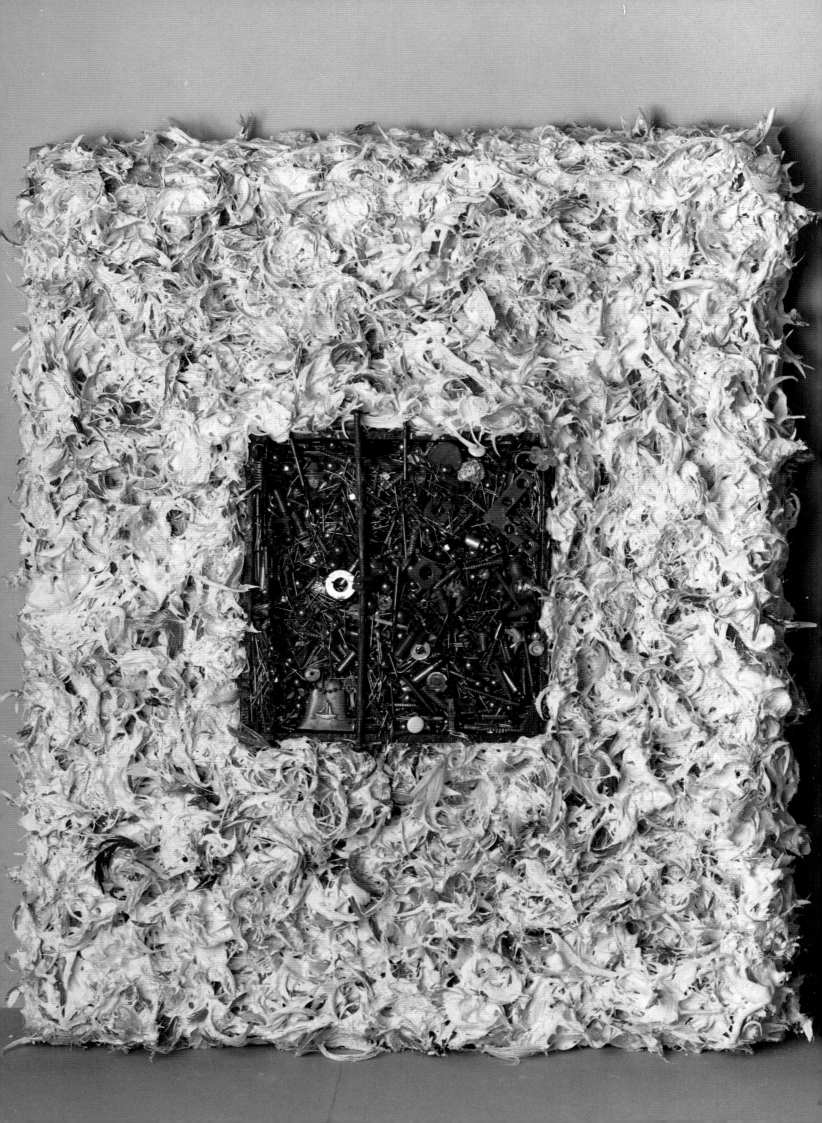

international movement established in part to "dadaize" the expressionism and concreteness of Happenings, employed many of the same tactics, events, and attitudes. It is no accident that one of its most famous members, Nam June Paik, the musician-conceptualist from Korea, went on to become a major voice in the development of conceptual video installations.

It was this new set of attitudes built upon older ideas that emerged from and encompassed musicians and performance artists, along with alternative art forms based on technology. These threads continued as a part of what may be called the Pop art aesthetic in the United States and Europe. The new attitudes also demonstrate a basic truth of Pop: it was born from what would eventually be called "conceptual" art, a realm wherein the stress is upon the concept rather than the form. This presents the ordinary viewer with a fundamental inversion of ideas because Pop art is usually best known and understood through its appearance and easy acceptance of objects from daily life. But in a media culture nothing comes into existence stripped of self-consciousness; neither advertising nor art. It was to be a new world where image and idea played at one remove from the physical world—a world, in short, of signs more than of symbols.

Is all of this Pop art? Yes and no. Yes, in Alloway's broadest sense of the term, because the artists took as their domain the contemporary artifacts of the world around them, often in emblematic ways; no, in the restrictive sense. Yet even those who would come to participate

Untitled

LUCAS SAMARAS, 1960–61; assemblage: wood panel with plaster-covered feathers, nails, screws, nuts, pins, razor blades, flashlight bulbs, buttons, etc; 23 x 19 x 4 in. (59 x 48.2 x 10.2 cm). Larry Aldrich Foundation Fund, The Museum of Modern Art, New York. Samaras's work in early Happenings—his concern for objects and transformation—link him to Pop art, but his concern for the personal expression of his own psyche sets him apart. His precious assemblages glitter to attract but repulse through sharp and threatening parts.

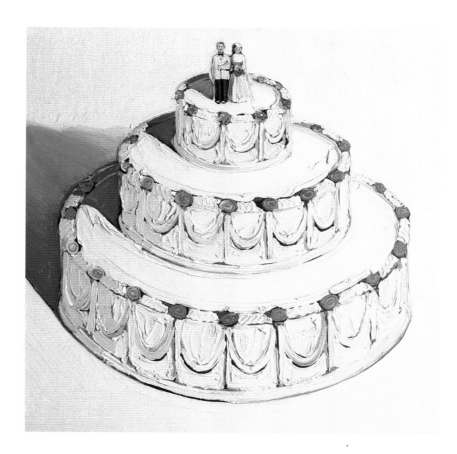

in the more confined realm—and they are the most well-known figures—emerged from this broader context, remained influenced by and often returned to it in one way or another.

New York—The Abstraction of Pop

In what has become a virtual urban legend, a young son of Roy Lichtenstein, then an abstract expressionist painter, reportedly came to Dad with a cartoon and asked him to make a "funny" for him. On such a mundane note was Pop art supposedly born. The "cartoons" were artifacts from what was then considered a popular culture, one we now recognize more precisely as created through advertising yet occupying a middle ground much the same way as do commercial Saturday morning television cartoons that sell products.

In the early 1960s commercial popular culture was seen less as a conglomerate extension of capitalism than an anecdotal antidote,

Wedding Cake

WAYNE THIEBAUD, 1962; oil on canvas; 39½ x 29½ in. (100.3 x 74.9 cm). The Newark Museum, New Jersey. Thiebaud combined common objects and a strong sense of modernist flatness typical of Pop art but also retained a love for thick pigment. The equation between the confectionery paint surface, shaped in powerful contours as if by a knife, and the cake frosting merged his art with reality in a new form of material illusionism.

a reaction against the sources and considerations of the serious approach embedded in Abstract Expressionism. The caveat came in the fact that many of the New York Pop artists were trained in the graphic arts of advertising; at the same time, they were familiar with abstract traditions derived from European modernism. Lichtenstein often discussed his "pop" work in terms of abstract expressionist field painting, which sounded much like ideas in a painting by Clyfford Still. Such explanations provide a crucial source to a number of qualities in Pop art that are not accounted for by simple references to popular culture. It is more fruitful to see Pop art as an historical hybrid than as a pure form.

Figurative artists usually associated with Pop art show the hybridization most clearly. Alex Katz created a unique style by openly combining the Abstract Expressionist concern for surface and large scale with the flat planes of graphic design from the world of advertising. But his subjects were people from the world around him. This allowed his works to reference several systems at the same time; they were real and abstract, frozen yet part of a narrative, symbolic but with no singular meaning.

More diagrammatic were the works of Larry Rivers, whose figures move purposively between realism and abstraction, depth and flatness, clarity and ambiguity, never resolving themselves. Rivers struggled to retain a sense of realism in a world where systems of information—which included the physical elements of style as equal to words as equal to concepts—remove us from the original experience. Nothing in this new world, implied Rivers, would be easy.

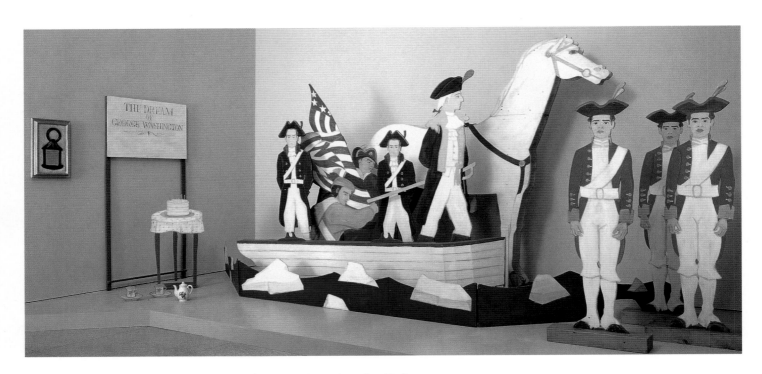

George Washington Crossing the Delaware

ALEX KATZ, 1961. National Museum of American Art, Smithsonian Institution, Washington, D.C. © 1997 Alex Katz/Licensed by VAGA, New York.
Designed for a theater performance, *Washington* stands as a perfect Pop interpolation of a moment in history rendered into the idiom of signs. The clear contours, simple composition, and planar colors Katz utilizes in his paintings are here as well, all typical of the generic Pop art idiom.

Parts of the Face: French Vocabulary Lesson

LARRY RIVERS, 1961. The Tate Gallery, London.

© 1997 Larry Rivers/Licensed by VAGA, New York, N.Y.

This work was done as part of a series using various body parts, male and female, and various national languages; Rivers matched them to his own devices as an artist—drawing, painting, line, and brush. Thus, as the 1960s will insist, art is like a language system with changeable parts that construct meaning.

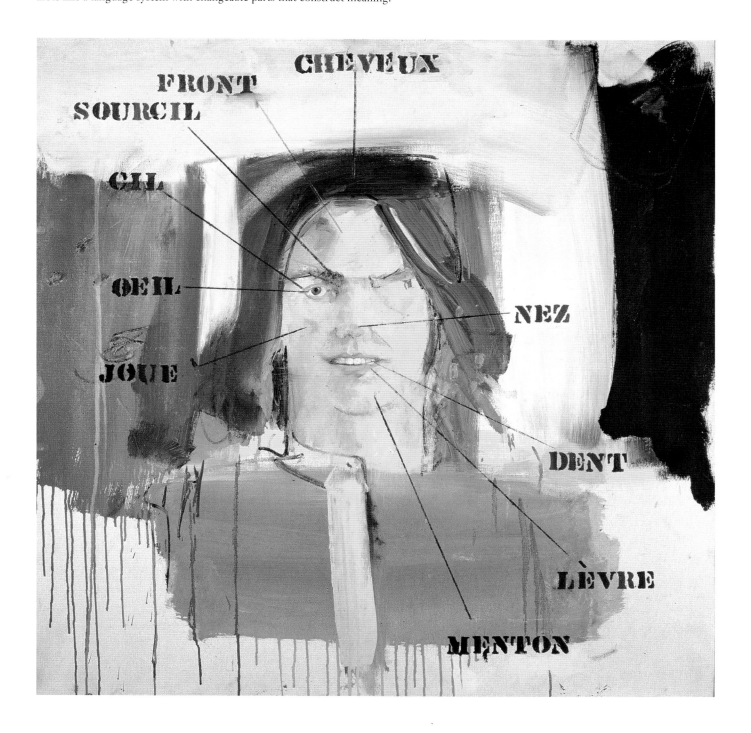

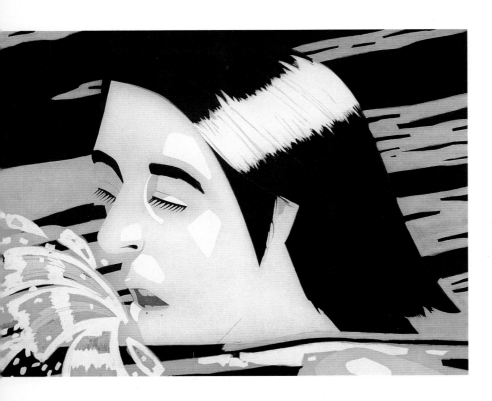

The Swimmer

ALEX KATZ, 1974; aquatint and drypoint, printed in black, composition; 28¹/₁₆ x 35¹³/₁₆ in. (71.2 x 91 cm). John R. Jakobson Foundation Fund, The Museum of Modern Art, New York. Katz was one of the first among the abstract painters to return to the figure, and although he calls for a new realism, the lessons of abstraction remain. His figures are less human than constructions that call attention to themselves as such. New is the cool air and emptying of emotional content, signifiers of Pop art.

Roy Lichtenstein

Roy Lichtenstein's art was simultaneously easy and complex in terms of both style and subject matter. His subjects by 1963 were taken frequently from comic books, ones relatively unknown but of decided typologies—war, romance, and detectives. It was the acceptance of what appeared to be straightforward figures involved in straightforward narratives that would be the centerpiece of commentary on Pop art for over twenty years. Interpreters read Pop art as the end of abstraction, the end of artistic developments begun in the 1880s, the end of creativity, ultimately the end of history as it was known, with a return, especially in Lichtenstein's art, to the human figure and plainly readable content. Interpreters lined both sides of the aisle, but mostly the negative side, a fact which served to endear the Pop artists in the eyes of American youth all the more. The critics were simply wrong. They missed seeing the ties between Pop art as abstract art and a new sense of realism ushered in through a designed visual culture.

Lichtenstein, much like Jasper Johns, saw more clearly the parallels that graphically designed art in the advertising world shared with modernist abstract art. The large areas of flat, bright color planes and the bold gestural quality of dark outlines became his self-conscious reference points of stylization. Content was constructed from lines and colors known to be abstract elements but now used in a self-conscious manner to reconstruct recognizable figures in simplified formulas.

As in style so in narrative. War and romance comics simplified life, reducing the complexities into an assemblage of emotional cues much the same way as space and form were now cued in the viewer who accepted such abbreviated language systems in the everyday world of media culture. Such was the impact of technological reproduction on human communication systems. And it was the communication systems—visual and emotional—that became the real subject matter and content of Pop art, its shared subtext. As Alloway pointed out, art was responding to "the communication system of the twentieth century," with its "field of exchangeable and repeatable imagery."

Pop artists, following the messages in Rauschenberg's and Cage's works, did not create in the traditional sense so much as re-contextualize a style and processes already familiar to people living in the modern communications system. This is the nucleus operation Pop art performs: re-presenting rather than unique creation. Using style in a manner as self-consciously as the fashion industry, the processes of stylization replaced the represented subject as the content.

Drowning Girl

ROY LICHTENSTEIN, 1963; synthetic polymer and oil paint on canvas; 67⅝ x 66¾ in. (171.6 x 169. 5 cm). Philip Johnson Fund and gift of Mr. and Mrs. Bagley Wright. The Museum of Modern Art, New York. © Roy Lichtenstein. As in war so too in romance—culture had accepted images that cued emotions rather than expressed them. Like many Pop artists, Lichtenstein gave greater weight to the viewer's abilities to extrapolate through this new system of emotional signs.

Athlete's Dream

LARRY RIVERS, 1956. National Museum of American Art, Smithsonian Institution,
Washington, D.C. © 1997 Larry Rivers/Licensed by VAGA, New York, N.Y.
Rivers as an artist is generally located somewhere between abstract and Pop
art. He was aware of art and its processes as a system of signals and codes,
and insisted on retaining the figure as an important issue for Pop art. Here
drawing, painting, figure, and abstraction share in the staging of the work.

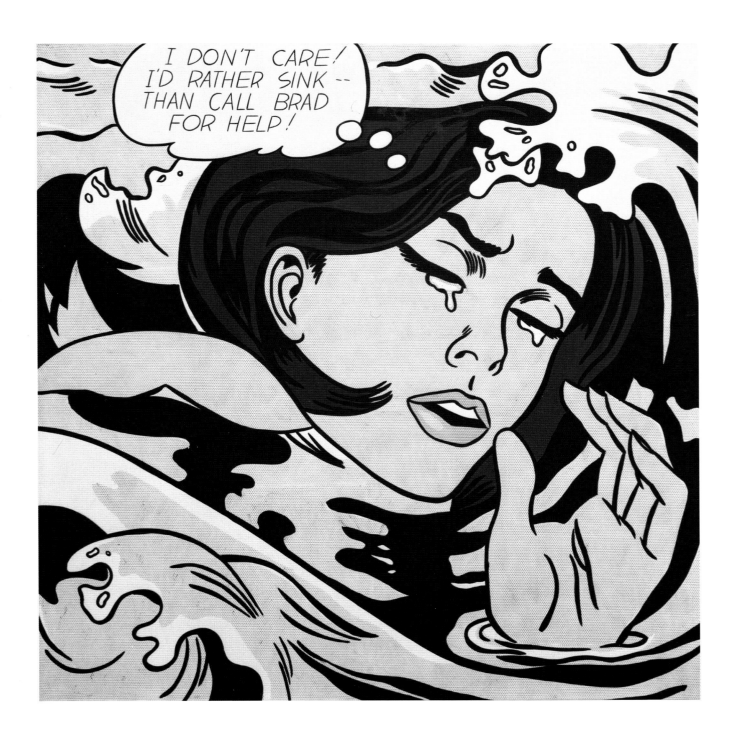

**Andy Warhol
at a Party at the
Bleecker Street
Cinema, New
York City**

*Photograph dated June 6,
1967. UPI/Corbis-Bettmann.*
In 1967 Warhol moved
to The Factory, at 33
Union Square West,
the site of a trendy
art-carnival atmos-
phere until he was
shot by an enraged
groupie/feminist in
1968. After that
The Factory literally
mass-produced both
silkscreen portraits
and fame while Warhol
strategically gave up
art for parties.

Andy Warhol

Despite Lichtenstein's ability to merge ab-
straction and representation, the acknowl-
edged master of the consequences of such
transformations was Andy Warhol. Trained
and while working as a graphic designer
Warhol independently arrived at cartoons as
a source for his art at the same time as
Lichtenstein but quickly moved to other areas.
His sources were images known from popular
advertising, such as Campbell's soup cans,
Brillo soap pads, dollar bills, Coca Cola bot-
tles, even newspaper photos of car crashes.
When it came to portraits, he chose Marilyn
Monroe, Elvis Presley, Jackie Kennedy, and
famous art collectors and personalities.

What these images shared was their life as
images within a system of advertising; soup
cans and people within this system were equal
as commodities, and in service of the same
goals; fame sought and achieved through expo-
sure and sales. No one bought an original;
everyone could own and use a reproduction or
a mass commodity.

Warhol freely addressed two seemingly
contradictory issues—his subjects were truly
famous yet he was advertising himself and his
art as pedestrian. To reinforce the latter he
chose images available in the public domain,
then used techniques that most people could
easily master, most notably silk-screen printing.
Apparently eliminated were the issues of cre-
ativity and craft. In fact there was a certain
sloppiness in his work that signaled a casual-
ness; the various colors of the silk screen were
misaligned deliberately. "You too could be an
artist" was part of the message.

If not a lie, it was of course a prefabricated
myth that derived from and accommodated
not only the idea of a deeply held American
faith in populism but its counter-belief: the
American public's deep-seated suspicion of
modern art in general—"Anyone can do that!"
One of the facets of Warhol's genius was his
ability to intuitively understand people and

the art system, merging them in intricate ways
and acknowledging the fact that they were
frequently in conflict.

This modernist self-consciousness of the
media now moved into the realm of play and
applied to the entire range of the communica-
tions system. Warhol ultimately adapted this
strategy to his greatest work of art, his own
persona. In this sense Alloway was wrong or
only partially right with regard to Warhol,
who saw that the subject was not simply the
newly ubiquitous communication systems of
the twentieth century but their many conse-
quences, particularly fame through multiplica-
tion. If one thing is good, argued Warhol with
the uncanny down-home logic of the surplus
market shopper of middle America, aren't a
hundred of them even better? How could the
art world, itself an emerging market place,
argue against someone who so well under-
stood the future?

Warhol surrounded himself with both the
famous and non-famous, mixing high and
low into an amalgam that shared qualities of
both. His studio in an old building on East
Forty-seventh Street became the site of many
events well beyond the making of visual art,
an art center and, literally, a "Factory," as he
named it. He had removed himself with the
comment that he wanted to be a machine but
one surrounded by a large cast of characters,
from junkies and wanna-bes to the rich and
fashion chic.

Brillo Box

*ANDY WARHOL, 1964; synthetic polymer and silkscreen on wood;
17 x 17 x 14 in. (43.1 x 43. 1 x 35.5 cm). © 1997 The
Andy Warhol Foundation for the Visual Arts/ARS, New York.*
As if in direct commentary to the conceptual
content of his art as "empty," Warhol created a
series of objects that were reproductions of
packages on hollow plywood boxes. The message
was clear: there was nothing there in this culture.

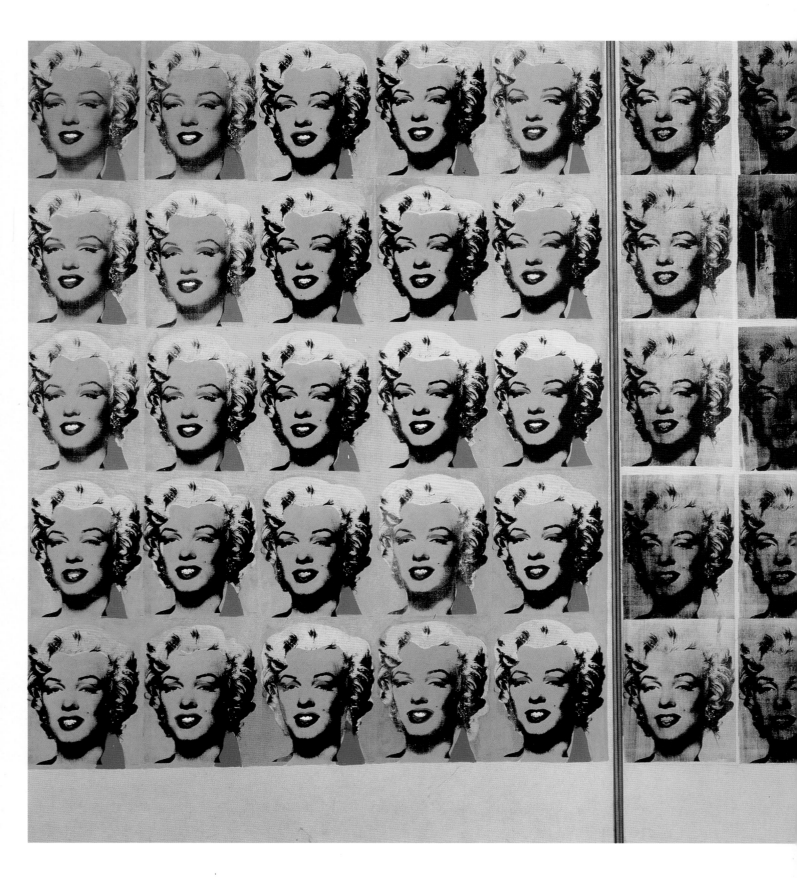

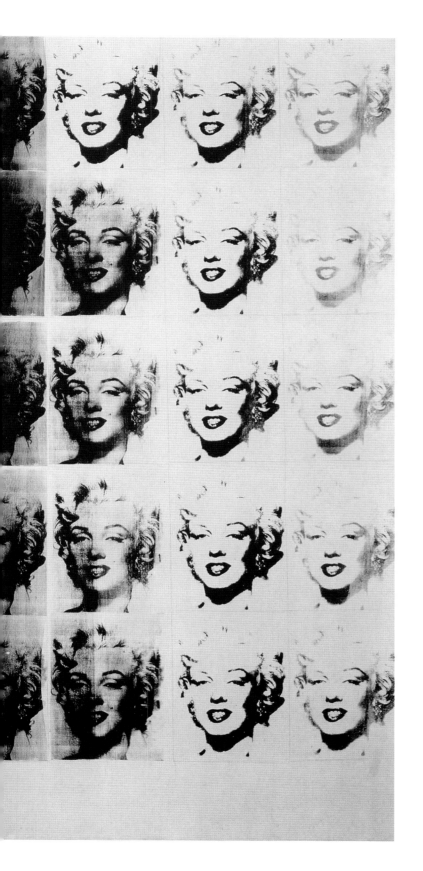

Marilyn Monroe

Bettmann Archive, New York.
Media images were im-
portant for Pop art as
the 1960s saw the rise
of the star cult. Few
were as iconic, both in
the United States and
in Europe, for the new
media culture than that
of Marilyn Monroe.
The perfect paradigm,
Monroe embodied the
slick, sexual desire of
the commodified cul-
ture while her "image"
was clearly a creature
of construction.

FOLLOWING PAGE:

210 Coca-Cola Bottles

*ANDY WARHOL, 1962; synthetic polymer paint and silkscreen ink on
canvas; 6 ft. 10½ in. x 8 ft. 9 in. (209. 5 x 266.7 cm). © 1997
The Andy Warhol Foundation for the Visual Arts/ARS, New York.*
Warhol's silkscreen reproductions of a single object empha-
sized the condition of a culture now vested in mass produc-
tion. It was a brilliant observation on the new media culture
and the shifts in the nature of reproduction it engendered.

The Marilyn Diptych

*ANDY WARHOL, 1962. The Tate Gallery, London. © 1997
The Andy Warhol Foundation for the Visual Arts/ARS, New York.*
Despite the public pose of ordinariness and ease,
Warhol chose famous brands and famous people
for his subjects. The supposed carelessness of the
silkscreen process called attention to the fact that
the images were constructions, just as the images
of stars and fame itself are purposeful constructions.

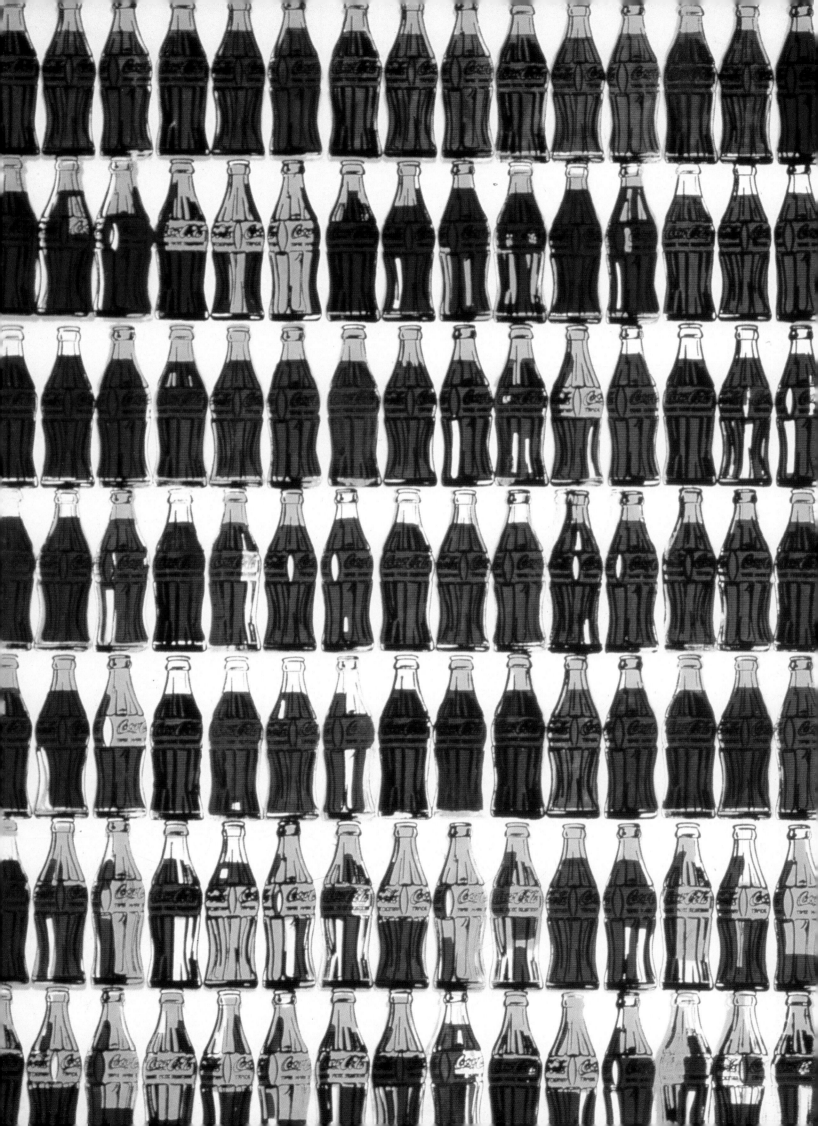

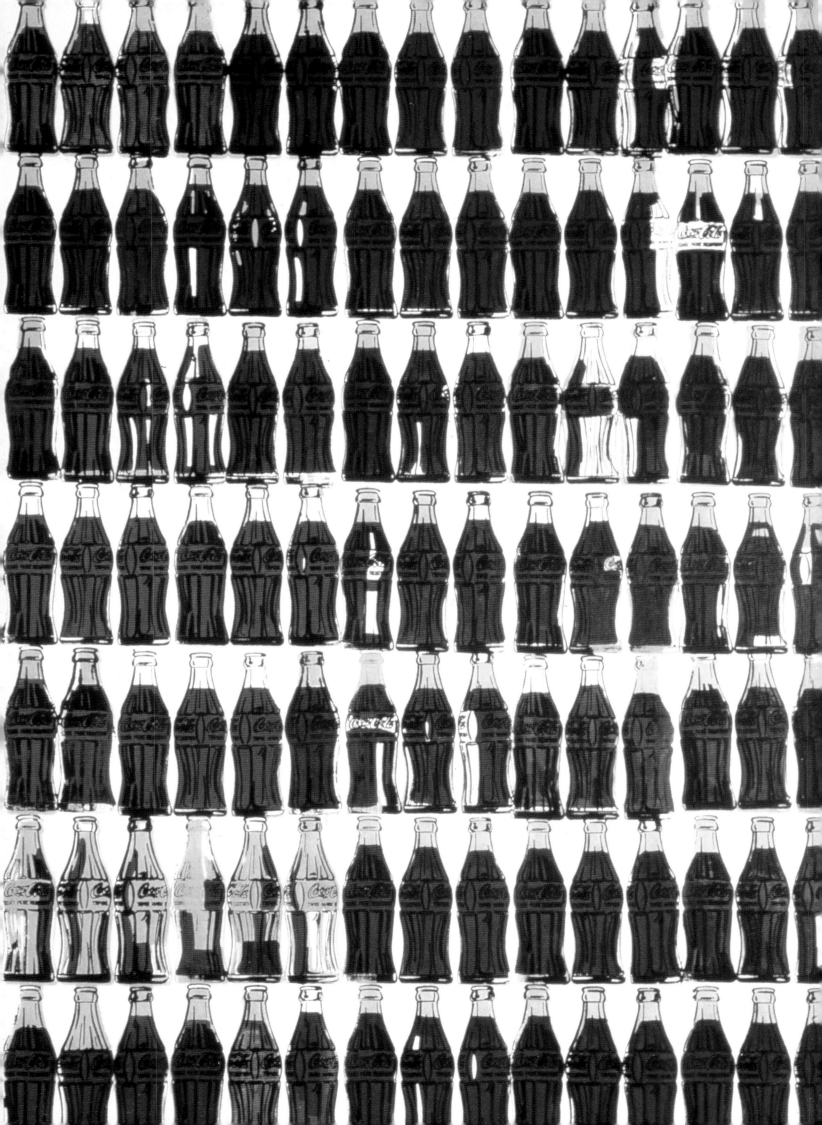

Scene from the Movie *Flesh*

ANDY WARHOL, 1968–69; 89½ minutes, color. Written, photographed, and directed by Paul Morrissey. Produced by Andy Warhol. The Kobal Collection, New York. Paul Morrissey converted Warhol's anti-genre filmmaking style into the first of a series of narrative films directed toward viewer interest and the box-office. One day in the life of a male hustler, played by Joe Dallesandro, *Flesh* retains Warhol's cast of characters from The Factory as well as the artist's sense of cool passivity.

The Factory began to produce stardom via underground movies in the mid-'60s made by Warhol, then by Paul Morrissey. The early film strips were made by locking the camera on, for example, the Empire State Building for eight hours or on someone sitting in a chair picking their nose or eating their lunch. They were purposefully boring and mundane, but the fame acquired through them was later used to promote more traditional narrative films made under but not by Warhol. Fame, as Warhol understood more than anyone else in the art world despite his glib protestations, was in the framing and context; fame was a construction. And fame was the goal of production; art was simply a part of this greater whole. As he famously noted, *he* was the art form, and by implication, it could also be *your* birthright.

All Power to the . . . Package!

Once you entered and were processed by the system, fame was awarded even if its longevity could not be guaranteed. But wasn't that also the nature of the system, as Warhol formulated in his oft-repeated phrase? Everyone should be entitled to a few minutes of fame.

The question then became, and to some extent remains, whether Warhol truly believed this or if his art and aesthetic were a pose in critique of the star system. The artist, though, had already outdistanced the very nature of the either/or question, much the way the media culture outdistances its critics. As Warhol lived his life and made art, it was now an and/also culture, an attitude toward art that matched the great leveling mechanisms within a commercially mediated world. You could be famous and common if you were in the right frame.

Unlike the Dadaists or even Rauschenberg, the object by itself was no longer sufficient for Pop artists; it was now only a reference point. All rhetoric about the role of objects in Pop art to the contrary, the artists understood the basic lesson, worth repeating, imparted by media prophet Marshall McLuhan: The medium is the message. In a world where the package, the frame, was more important than what was inside the box, reference to the thing itself no longer held sway. Fact was exterior and superficial, not a deep and interior truth. In the words of the immortal Gertrude Stein on Los Angeles, "There is no there there." And this changed the nature of the world. This made the object—used in the sense of the objective world—merely the reference signaled to consumers by the packaging. All power to the package!

Myths: Aunt Jemima

ANDY WARHOL, 1981; synthetic polymer paint and silkscreen ink on canvas, 60 x 60 in.
(152.4 x 152. 4 cm). © 1997 The Andy Warhol Foundation for the Visual Arts/ARS, New York.
Although Warhol took on more commercial work and a commercial look
in the 1970s and '80s, he retained his wit and insight. His series of myths
in America, ranging from Aunt Jemima to Mickey Mouse, fingered with
acute perception the socialized conditions of a commercialized culture.

Claes Oldenburg

Claes Oldenburg had been active in the development of Happenings and accepted much of the junk aesthetic. The object was necessary but as a reference point—less an object and more the idea of an object. Thus he began by making objects that paralleled objects in the everyday world but never as closely as the more graphic paintings of Lichtenstein and Warhol.

Oldenburg's objects mimicked the world in rough parallel, and they wore their roughness on the outside. Plaster of Paris pastries from soda fountain counters and cafeterias whose displays advertised America as a land of

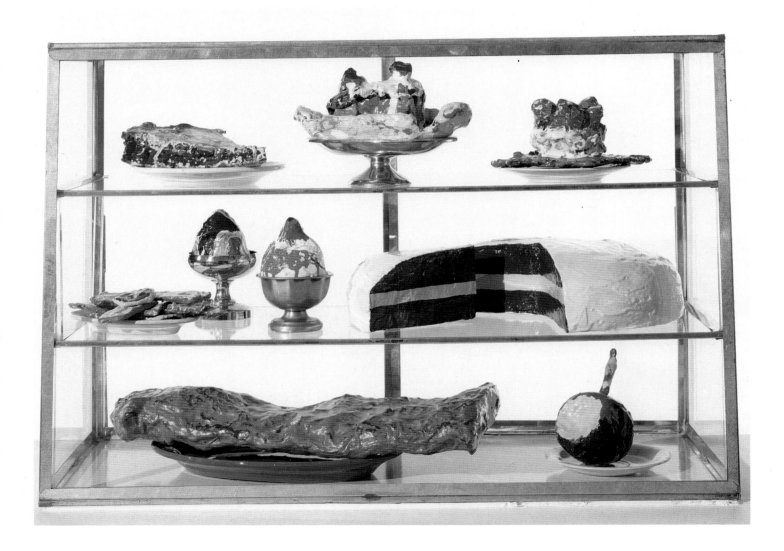

Pastry Case, 1

CLAES OLDENBURG, 1961–62; enamel paint on nine plaster sculptures in glass case; 20¾ x 30⅛ x 14¾ in.
(52.7 x 76.5 x 37.3 cm). The Sidney and Harriet Janis Collection, The Museum of Modern Art, New York.
A night job as a dishwasher scraping food led Oldenburg to a visualization of food as art.
In December of 1961 he opened *The Store* on the Lower East Side of Manhattan to sell
his new line of "products and commodities": handmade art for sale at cut-rate prices.

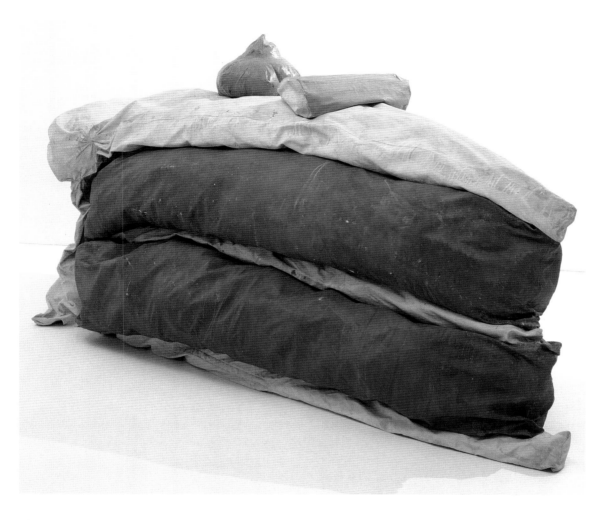

**Floor Cake
(Giant Piece
of Cake)**

CLAES OLDENBURG, 1962; synthetic polymer paint and latex on canvas filled with foam rubber and cardboard boxes; 58³/₈ in. x 9 ft. 6¹/₄ in. x 58³/₈ in. (148.2 x 290.2 x 148.2 cm). Gift of Philip Johnson, The Museum of Modern Art, New York. Oldenburg solved the problem of filling a large, new space for his first gallery exhibition in typical fashion. He gave his works a sense of presence through an enlarged scale that matched that of cars in an auto showroom. The move to soft forms was made for ease, expense, and fun.

plenitude were created and covered with bright, gaudy, cheap enamel colors. The market became the model, as Oldenburg turned his studio storefront in Manhattan's Lower East Side into *The Store* and affixed to his objects cut-rate price tags like those used in department stores and open grocery-market bins. Laughter was the best antidote and Oldenburg, as testified through his drawings, saw himself as the clown. But his was a clown with designs and a full appreciation for much of modern European art theory.

The small foodstuffs and articles of clothing had by 1962 turned into larger, hand-sewn, and stuffed versions of their former lives. The gallery-goer now walked among chest-high pieces of cake and hamburgers stitched from canvas and situated on the floor. These were

constructions any child could appreciate; indeed, the child ruled, since the small world now dominated by an increase in scale.

Scale was an important tool of transformation. In a nod to the Surrealists, whose ideas along with those of primitivism had dominated Chicago where he was raised and trained, Oldenburg purposefully used the shock of the change in scale to liberate the viewer from the confines of any prior thought about "art" or object. Yet unlike the Surrealists, these were cheeseburgers and not poetic-objects; there was a blatant crudity and a belly laugh here that matched the artist's New York street environment and his love for the grittiness of urban life. But the objects were transitional objects, developing from the child psyche of Oldenburg through a conflation of self-portraiture and eroticism.

Oldenburg loved drawing and in his drawings the theme of metamorphosis, frequently in conjunction with a sexual polymorphism, is plainly stated. Women's breasts become the twin blades on an eggbeater and at the same time they are a reference to Buckminster Fuller's Dymaxion House project and a spaceship, while the bundled electric cord acts as phallus, the male now attached to the female.

While the "female" receptacle receives a phallic electrical prong, the electrical plugs drawn overly large suggest interchangeably a house and a fireplug. The world of creativity, one apparently and strategically abandoned by Warhol and Lichtenstein for pre-made sources, lived on in Oldenburg.

By 1965 an obvious sensuality was stressed when Oldenburg began making his objects in soft vinyl formats. The surfaces were now "fleshy" but cosmetically chic, while the objects chosen, such as drum sets and toilets, were as conceptually ridiculous as they were visually funny. Oldenburg remarked that he loved to look at the works every day since they differed due to the effect of gravity. Nature was transforming them by chance operations much as he had through his drawings and ideas.

At the same time, Oldenburg made a commitment to large-scale monuments that could be "made" only in his dreams and drawings. By the late 1960s and for the rest of his life he was able to fabricate them at the scale if not always the location he intended. But to show that the site of objects was within the mind and conceptual, many of his unmade works—such as the melting good humor bar for the middle of a New York City street or the twin toilet bowl floats for the polluted Thames in London—were as humorous in sketches, hence concept, as they would have been if built. There was much of Duchamp and the Dadaists in this American clown.

Tower

RICHARD ARTSCHWAGER, 1964; painted formica and wood; 6 ft. 6 in. x 24 1/8 x 99 in. (198.1 x 61.1 x 99 cm). Gift of Philip Johnson, The Museum of Modern Art, New York. © 1997 Richard Artschwager/Artists Rights Society (ARS), New York. Artschwager moved from craftsman making wooden objects into the visual arts through the influence of Claes Oldenburg. He first brought his "objects" with him, painting blocky, vastly simplified forms that suggested functionality. Later he reversed the relation by making abstract furniture/sculpture.

Giant Soft Fan

CLAES OLDENBURG, 1966–67; construction of vinyl filled with foam rubber, wood, metal, and plastic tubing, fan: 10 ft. x 58 7/8 x 61 7/8 in. (305 x 149.5 x 157.1 cm), variable; plus cord and plug, 24 ft. 3 1/4 in. long (739.6 cm). The Sidney and Harriet Janis Collection, The Museum of Modern Art, New York. Switching from canvas to vinyl exteriors, Oldenburg continued his soft works not simply for the ludicrous element, although that was important, but because they sagged and were transformed by gravity each day. This welded the Dada principle of chance to the Surrealist ideas of transformation and irrationality.

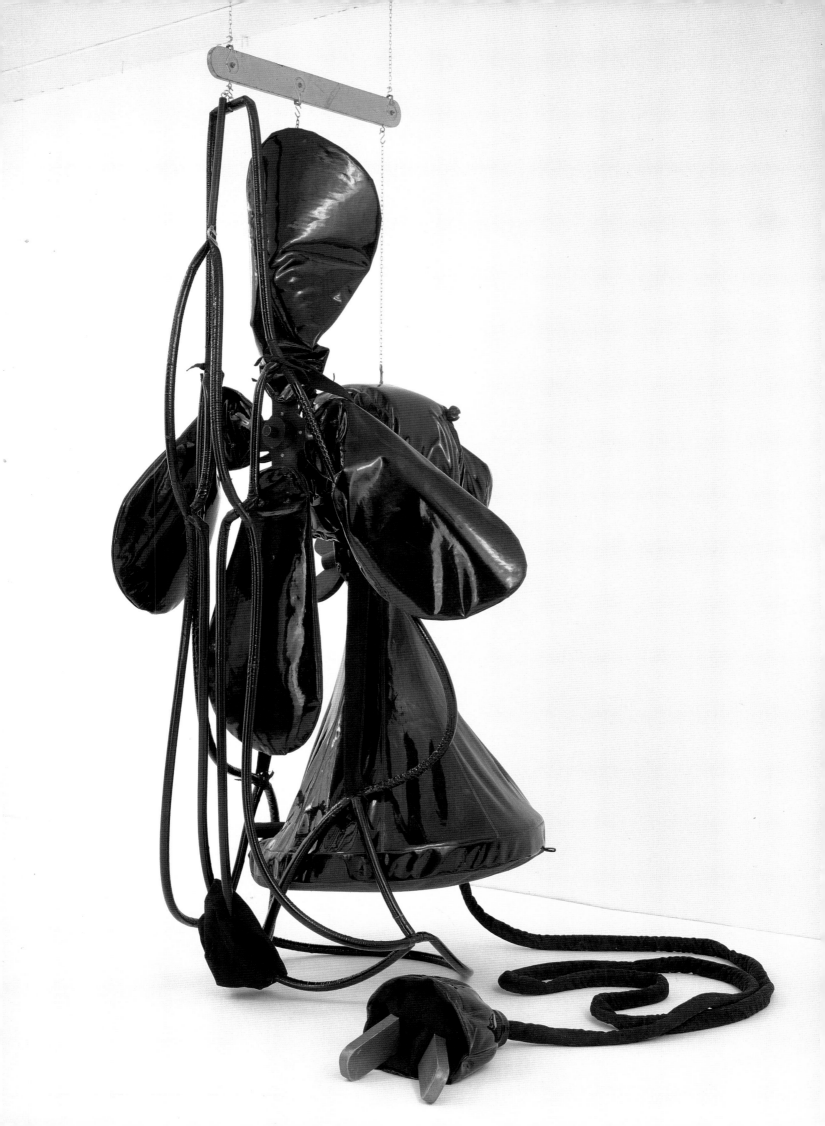

The Signs of Pop

For a culture surrounded by signs Pop artists made signs, and in the case of several artists this was almost literally so. James Rosenquist, who worked professionally on large billboard paintings, mixed in his work the obvious directness of signs with the more complex language of abstract composition, requiring the viewer to decipher the imagery. Unlike most Pop artists, imagery remained important for Rosenquist, in combination with the typical self-conscious references to the processes of painting and creation. In his much acclaimed 1964 master work, the 10 by 86 foot (3.3 x 28.3 meter) *F-111*, designed to wrap around the gallery walls as an environment, the images of popular culture are united by the prevailing images of war with a smiling child whose mechanistic style "hair-dryer"

simultaneously puts her in the pilot's seat and at ground zero.

More literal still are the signs of Robert Indiana, whose brash and contrasting colors and stenciled words relate to the earlier works of Stuart Davis and are derived from the same sources—American commercial culture. That Americans love clarity is testified to by their adoption of Indiana's most famous "word" from the 1960s, rendered in sculptures large and small and posters everywhere: love.

Allan D'Arcangelo turned away from his earlier social satire to demonstrate how the style of abstract, hard-edge painting could be aligned to signify the American love affair with highway travel and road signs. It is no accident that his long blacktops with their white divider lines are vacuous inscriptions of a culture whose only highlights are corporate gas logos.

The Meeting

RICHARD LINDNER, 1953; oil on canvas; 60 in. x 6 ft. (152.4 x 182.9 cm). Given anonymously, The Museum of Modern Art, New York. © 1997 Artists Rights Society (ARS), New York/ADAGP, Paris. Lindner brought his slick style of figure painting and sexual if perverse psychodramas out of a Germany untouched by Pop art. New York "discovered" him when Pop art affirmed figures, narratives, graphic styles, and general erotics.

Marilyn Monroe, I

JAMES ROSENQUIST, 1962; oil and spray enamel on canvas; 7 ft. 9 in. x 6 ft.¼ in. (236.2 x 183.3 cm). The Sidney and Harriet Janis Collection, The Museum of Modern Art, New York. © 1997 James Rosenquist/ Licensed by VAGA, New York, N.Y. Marilyn, a sign of the times, was born from Rosenquist's experience in sign painting and a modernist awareness of the flatness of the canvas as the primary fact of painting. Thus Pop art did not reject preexisting notions about art, but reincorporated them into a new context.

Highway U.S. 1, Number 5

ALLAN D'ARCANGELO, 1962; synthetic polymer paint on canvas, 70 in. x 6 ft. 9¹/₂ in. (177.6 x 207 cm). Gift of Mr. and Mrs. Herbert Fischbach, The Museum of Modern Art, New York. © 1997 Allan D'Arcangelo Licensed by VAGA, New York.

The imagery as well as the mood of a culture fascinated with highways, cars, and travel provide one of several consistent subthemes to Pop art. D'Arcangelo uses the isolated, literal signs of the road to convey a sense of the meaningless rush forward that mistakes movement for progress.

Still Life Painting, 30

Tom Wesselmann, 1963; assemblage: oil, enamel, and synthetic polymer paint on composition board with collage of printed advertisements, plastic artificial flowers, refrigerator door, etc.; 48½ x 66 x 4 in. (122 x 167.5 x 10 cm). Gift of Philip Johnson, The Museum of Modern Art, New York. © 1997 Tom Wesselmann/Licensed by VAGA, New York, N.Y.

Wesselmann's so-called still lifes were actually a combination of painting and environments. In his attempt to address an old tradition in modern terms he combined traditional, illusionistic painting with real items appropriated from consumer culture, moving eventually into life-size installations.

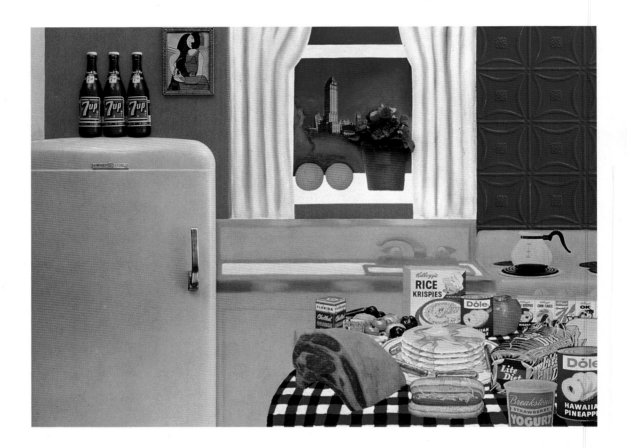

The paintings of Tom Wesselmann also referenced the packaged goods of American culture, from grocery stores and kitchen tables to sex. His still-life paintings of home interiors and canned goods often installed "real" plastic refrigerators and tables to point out a world where the difference between commercial fact and home reality was blurred. The installation artists had to look no further than their local store or mini-mart displays. Wesselmann's *Great American Nude* series referred to the soft-core pornography in men's glossy magazines as the basis for an abstracted re-presentation of eroticized female body parts with blank faces; the American woman here is reduced to sexual codes to create and fulfill male sexual fantasies. Critique or celebration? That was always the question surrounding Pop art.

Pop art in New York dealt openly with the nature of a culture wherein the physical fact of signage was the new condition and with the possible consequences such a new version of culture suggested. As Duchamp had earlier observed through his works, people and images create a complex dialogue where values shift indiscriminately; the Pop artists dealt with an entire industry whose purpose was to foster precisely such an interchange. It is a conversation and set of conditions that has yet to cease.

The American Dream, I

Robert Indiana, 1961; oil on canvas; 6 ft. x 60⅛ in. (183 x 152.7 cm). Larry Aldrich Foundation Fund, The Museum of Modern Art, New York.

Indiana wielded a hard-edge painting style from the mainstream of abstract art and redirected it back into the mechanical and commercial signage he invented as an analogue to the American experience. To make it personal, Robert Clark took the name of the state of his birth.

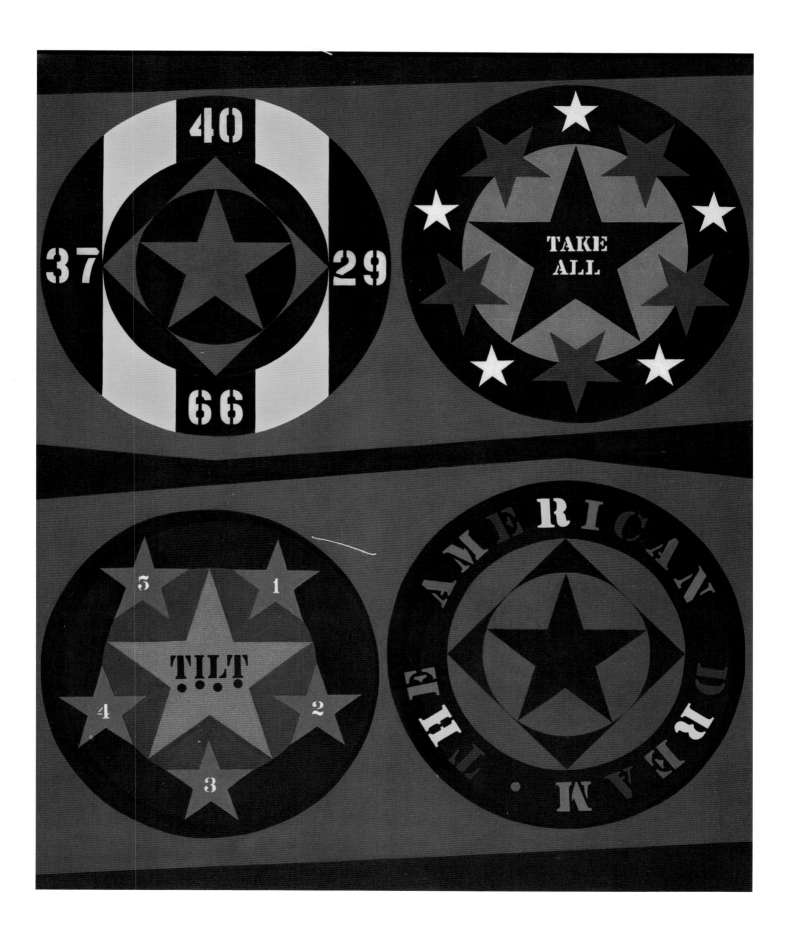

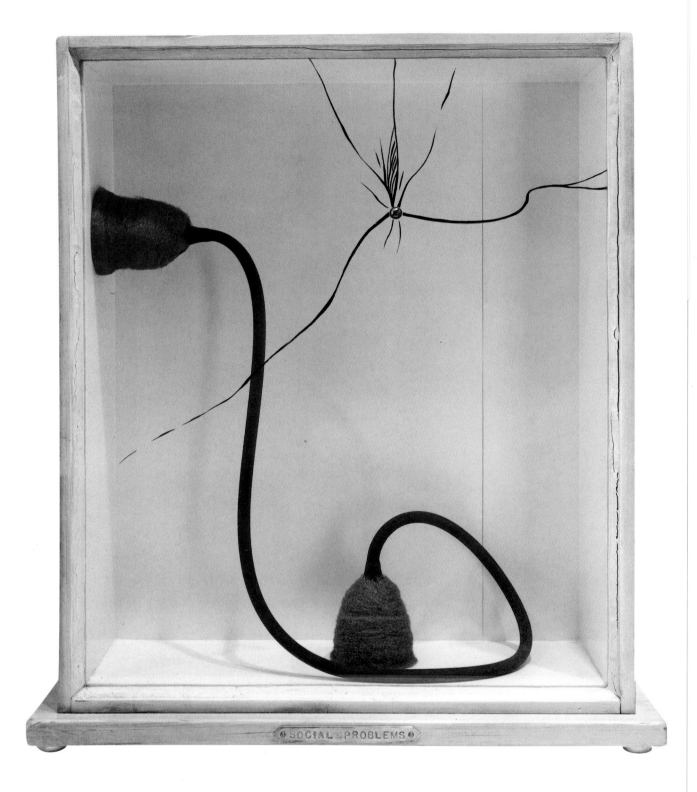

Social Problems

H. C. WESTERMANN, 1964; pine, glass, rubber, steel, wood, metal, and paint; 22¹/₂ x 18³/₄ x 7 in. (57.1 x 47.6 x 19 cm).

Robert F. and Anna Marie Shapiro, Barbara Jakobson and the Norman and Rosita Winston Foundation Inc. Funds,

The Museum of Modern Art, New York. © 1997 Estate of H. C. Westermann/Licensed by VAGA, New York.

The absurdity as well as humor in the human condition is the consistent subject matter for Westermann's decades of drawings and sculptures. The inventiveness and the solid warmth in his wooden materials and craft offset the isolation of our predicaments—the artist is right here with us.

Chicago & the West Coast

Although predictably smaller in size, developments on the West Coast or in Chicago were not as restricted in their direction as was New York Pop. Whether the words Pop art can be applied in either location with any information value remains questionable.

Both regions retained a decidedly "funkier" attitude toward art, drawing on the wider range of sources and values that had been forsaken in New York by 1962. There were exceptions to this, as there are with all generalizations about art, but there remains a certain pride over the distinctions between the slick graphic sophistication of New York Pop and the rawer, more expressionist developments in the West.

Chicago Who?

Although it is erroneous to reduce a complex urban art center to one or two ideas, post-1945 art in the city of Chicago was home to diverse but related ideas in the ethnographic art of the non-Western world, European expressionism, and Surrealism. Dubuffet's ideas concerning "art brut" were warmly received in Chicago by the early 1950s, which with its street-wise, healthy dose of European existentialism in the late 1940s, made for a tough art that had always accepted figurative and narrative art traditions as well as the necessity for art to embody a tortured social attitude. These had little to no parallel in New York.

Throughout the 1950s H. C. Westermann, originally a member of image makers in Chicago who embodied a more tortured, existential attitude in their figures, turned away from the personal psyche and into a public if ironic form of folk art. His fetishistic use of wooden structures, irreverent forms, and references signaled an open acceptance of psychological disturbance transported to a realm somewhere between humor and pain. One felt this was the domain of habitation for the artist as well, of someone who had participated in the carnage of wars and now came to grips with it through a dark sense of humor. It was Westermann's tone more than his facts that sent a message to younger artists in the 1960s, generally but not always accurately grouped under the umbrella of "Hairy Who."

For younger artists who admired the vernacular forms of folk art for their obsessive qualities "outside" the niceties of the art world, the mediated world of television, comics (especially the counterculture's underground comics), and kitsch served as an ersatz urban folk culture. The Hairy Who became a general title for a group of artists exhibiting in the mid-to-late 1960s. Painters like Jim Nutt, Karl Wirsum, Art Green, and Roger Brown, an artist outside the official Hairy Who group, employed a graphic comic-book style similar to Lichtenstein's but to radically different and parodic ends.

Wirsum, Green, and Nutt frequently used a raw, pre-pubescent sexual humor combined with puns which relates to but simultaneously mocks European traditions of concrete poetry through a phonetically free-wheeling yet rhyming, no-sense, street argot.

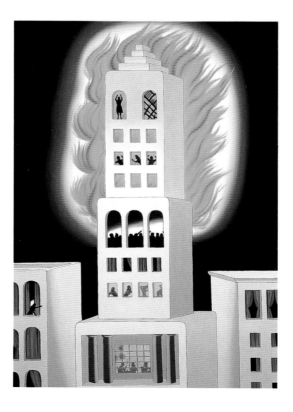

World's Tallest Disaster

Roger Brown, 1972. National Museum of American Art, Smithsonian Institution, Washington, D.C. The viewer looks into worlds created by Brown to watch, perhaps to imagine, the drama play out against the graphic quality of a style that argues the image as image rather than as reality. Where then are our emotions located?

Bob Bee
Pin Magnet

KARL WIRSUM; acrylic on
canvas. Photo courtesy of
the Phyllis Kind Gallery,
New York and Chicago.
The vivid life Wirsum
embeds in his figures
through the vitality of
color saturation, con-
trast, image, and puns
re-present the jive
energies of the streets
that the Chicago
School took pride in
calling home.

It's a Long Way Down

JAMES NUTT, 1971; acrylic on wood; 33⅞ x 24¾ in. (86 x 62.9 cm.). Gift of the S. W. and
B. M. Koffler Foundation, National Museum of American Art, Smithsonian Institution, Washington, D.C.
Nutt's figures are mini-performative libidinal psychodramas which imply sexuality
and eroticism through form and style, typical of the Hairy Who but remaining
unnamed and undefined, akin to the Freudian understanding of instincts and drives.

Holy Stick Man

ED PASCHKE, 1969; oil on canvas; 28³/₄ x 24¹/₂ in. (73 x 62.2 cm). Photo courtesy of the Phyllis Kind Gallery, New York and Chicago.
The freaks of Paschke's early Chicago paintings speak several languages simultaneously, from the circus sideshow to that of street-hip night crawlers. But the denizens long accepted as familiar stereotypes also look at us; we are observers, made conscious of our own complicities.

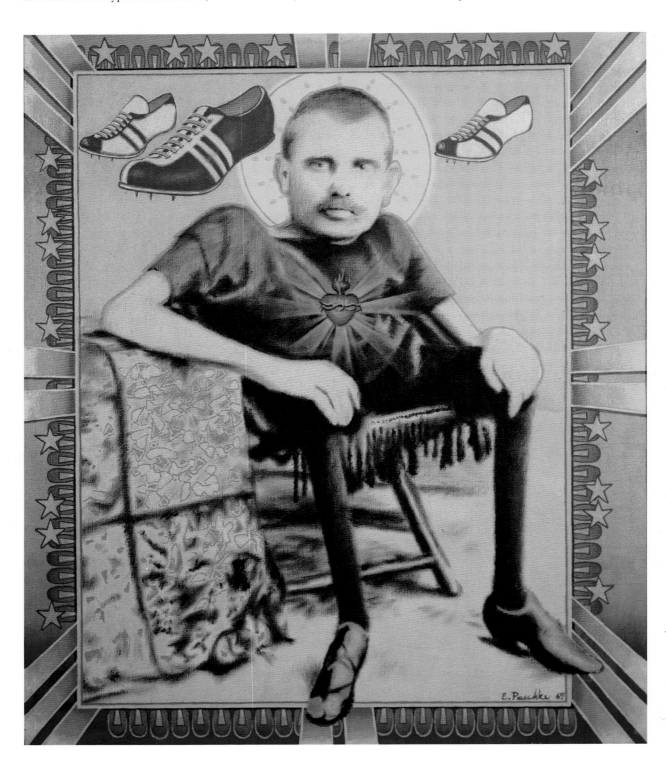

Gladys Nilsson's watercolors, whose titles and concepts derive from the same stream of street and media consciousness, counters the graphic patchwork simplicity of the others with complex biomorphic forms that cross Surrealist fantasy with the Blue Meanies of the Beatles' *Yellow Submarine* in textured wonders. Ed Paschke, another artist associated with the Chicago imagists, often played a sterling academic technique of body modeling against slicker graphic images, applied to true societal outsiders—side show freaks, prostitutes, and vagabonds of night and street culture. His stylization, then and now, speaks as much to the content as the subject.

Chicago's sense of "otherness," often implied in the phrase Second City, was now used to establish its own sense of community and identity, one that has haunted the so-called Chicago School since that time. But their general acceptance of the mundane, if not outré, can be seen as examples of the street anthropology Alloway spoke of as the broader context for Pop art. New York had its junk aesthetic or slick graphics and Alloway and the British treasured science-fiction books and posters; Chicago was more *Mad Magazine* and *Zap Comix*.

The Beatles Pose in 1967

Photograph dated June 18, 1967. UPI/Corbis-Bettmann.
Paul McCartney, Ringo Starr, John Lennon, and George Harrison emerged from the Liverpool art scene in the early 1960s in the Edwardian suits of 1950s Britain. But as they came to reflect the counterculture that rejected the materialism at the heart of much of Pop art, they helped also to create its forms and ideas.

FOLLOWING PAGE:
Beautious Horeazontal Ptng.
GLADYS NILSSON, 1970; watercolor on paper; 20⅞ x 30⅝ in. (53 x 77.7 cm.). Photo courtesy of the Phyllis Kind Gallery, New York and Chicago.
The complexity of Nilsson's imagery is typical of the Chicago Hairy Who artists, for whom multiple, dense forms and transformations mark off a purposeful zone of incomprehensibility that creates a zany but tart analogue to the creative realm of the human unconscious.

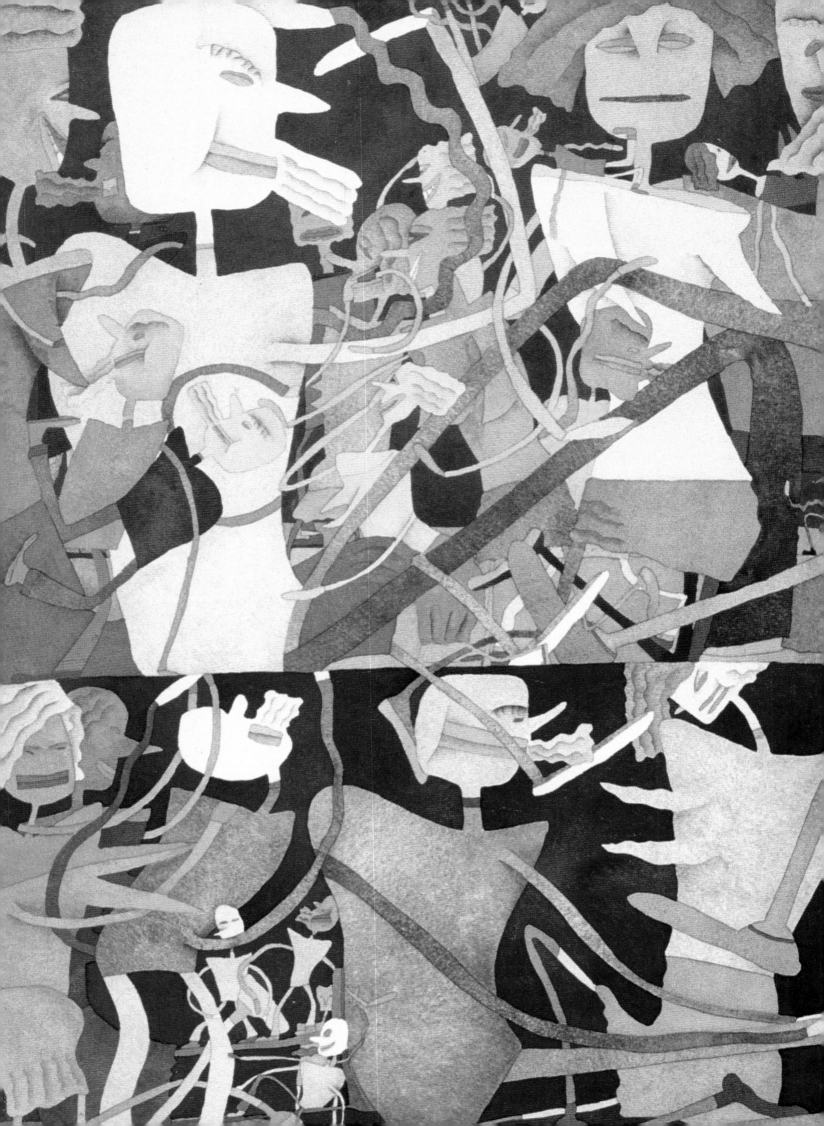

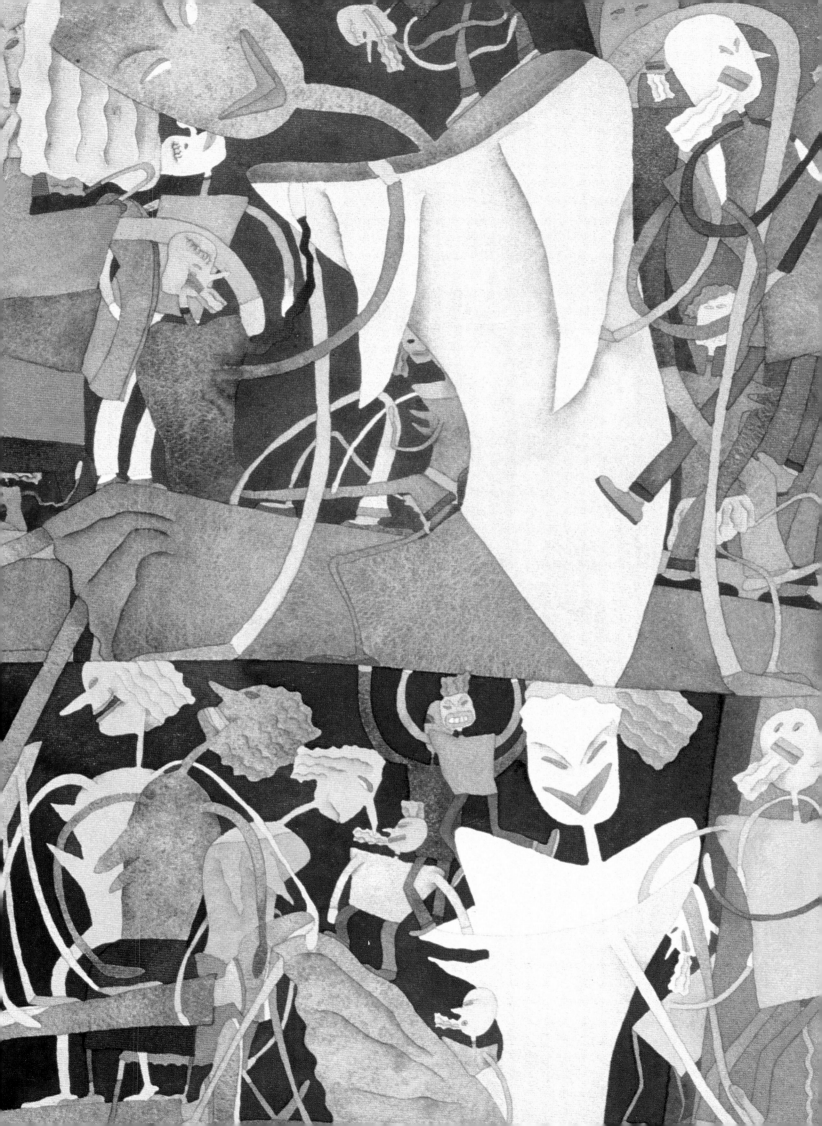

The West Coast

The freeway system, outdoor health, and Hollywood all played a role in the subject matter and style of Pop art in the Los Angeles area but did not generate as much of a distinct attitude as the Bay Area in San Francisco.

Mel Ramos's "girlie" paintings used a slick air brush–styled surface, the same used for vans and motorcycles, to represent the wholesome female nudies of Southern California media fame, usually alongside a cheesy ad reference, such as found in slick advertising calendars. There is no irony here—only simple deadpan, expected to play both sides of the street.

Much more sophisticated were the letterings and gas stations of Ed Ruscha. Words had always been important in Pop art, with their basis in advertising and media culture, but Ruscha moved letters into their own kind of reality. The logo or the word—the semiotic signifier—was the reality in a culture where there were

levels of meaning stacked one upon another. Ruscha's paintings of Standard gas stations signaled the conspicuous American road culture and the emergence of a corporate standardization that would constitute the new universal cultural literacy. They also reference through their use of a certain style—the clean hard edge and the red, white, and black colors—the failed utopian promises of the Russian Constructivist artists from the 1920s.

The overall graphic quality marks the LA tradition, but re-viewed through an art world familiar with the multiplying effect of meaning within communication systems. On a third level, there are frequent and complex references to the mixed realities of old-fashioned painting, a modernist self-consciousness of a flattened picture plane, and the objective world; the prior clear outlines of singular meanings and readings were now shimmering desert mirages.

Large Trademark with Eight Spotlights

ED RUSCHA, 1962;

oil on canvas; 6³/4 x 133¹/4 in. (169.5 x 338.5 cm). Percy Iris Fund, The Whitney Museum of American Art, New York. In Ruscha's work, word precedes image, and paintings are considered word images. Here, as in similar works, banal logos are treated via their context. In this case the searchlight drama of Hollywood carries a visual and cultural weight given graphic form— hype equals reality.

85

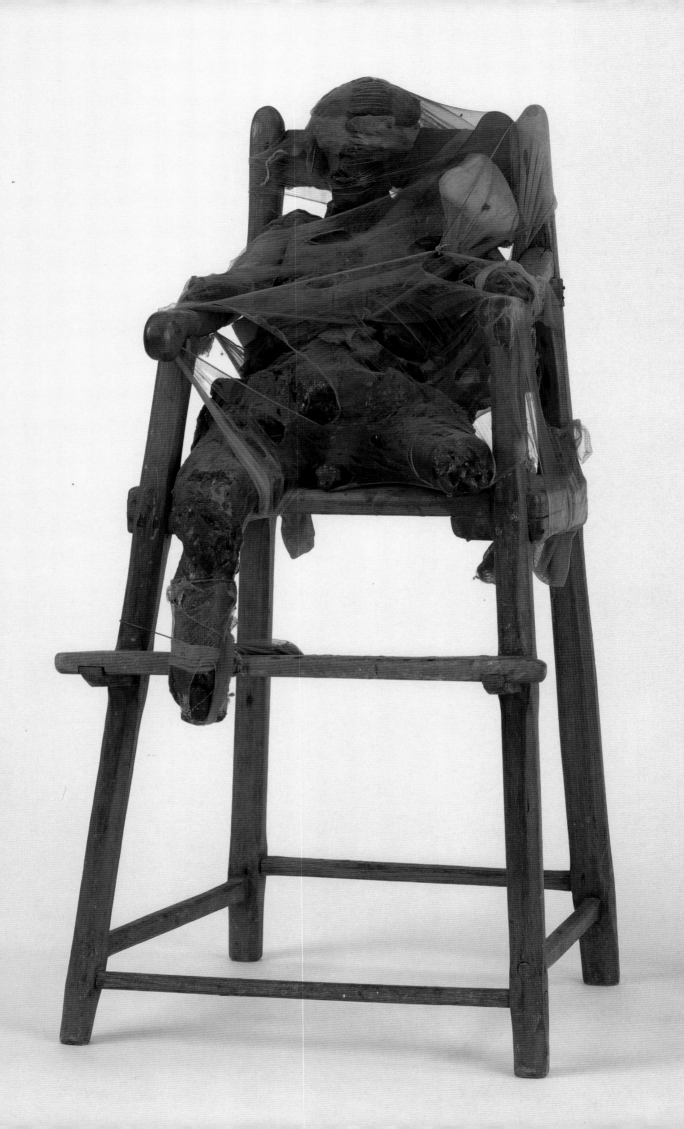

San Francisco, a center to the Beat culture that accepted the rawer elements of street life mixed with an American version of existentialism and Zen Buddhism, produced art that echoed its attitude. Not unlike Chicago there was a proud edge to works that mixed horror and humor within the same domain. The word *funk* was used to connote many aspects of this art. It was a dirty, loose improvisational style that accepted crudity without intellectual challenge but with a kind of cool morality. Many of these artists had a sense of social conscience not found in New York, or even in Chicago. At times the rawness was carried to the brink of absurdity, where the viewer was frequently balanced simultaneously in the world and outside of it at the scene of horror.

Both Bruce Conner and Edward Kienholz were assemblagists who explored this territory of horror and humor. The ceramist Robert Arneson did so with subject matter derived from bad puns and raunchy humor and "funky" textured and colored clay surfaces that were not unlike the painted expressionist surfaces of Joan Brown. At other times *funk* was applied to the slicker if highly eclectic assemblages of metal sculpture by Robert Hudson and the purposefully incoherent collages of the scientist-poet-artist Jess Collins.

In many ways the vulgarity of the San Francisco and Chicago areas constituted a critique of the banality seen and implicitly accepted in New York and Los Angeles. Pop and Funk displayed remarkably different attitudes about similar sources and demonstrated how precarious the line is between the neat, clean categories of history and knowledge. That one could "transform" into the other through slight inflections verified the mobile nature of meaning within the new cultural conditions of the postmodern world.

Child

Bruce Conner, 1959–60; assemblage: wax figure with nylon, cloth, metal, and twine in a high chair, 34⅝ x 17 x 16½ in. (88 x 43.2 x 41.9 cm). Gift of Philip Johnson, The Museum of Modern Art, New York.
Working on the West Coast of the United States, Conner was associated with the San Francisco Bay area school of Funk art, which concentrated on a grimier, more visceral set of images; the work often moved beyond the beat-style counterculture to something more stark and terrible in implication.

The Friendly Gray Computer—Star Gauge Model #54

Edward Kienholz, 1965; motor-driven assemblage: aluminum rocking chair, metal case, two instrument boxes with dials, etc.; 40 x 39⅛ x 24½ in. (101.3 x 99.2 x 62.1 cm) on aluminum sheet 48⅛ x 36 in. (122 x 91.5 cm). Gift of Jean and Howard Lipman, The Museum of Modern Art, New York.
Considered part of the West Coast Funk school of art, Kienholz's humor had lighter bounds but he never altered his role as a direct commentator on social and political conditions, an atypical attitude in Pop art. The problematic concept of a friendly computer is perhaps more relevant in the 1990s that it was in the 1960s.

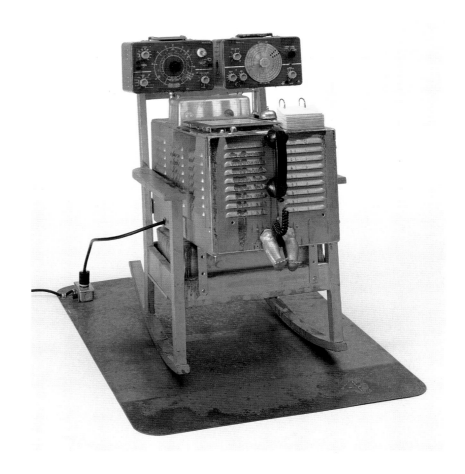

Standard Station

*ED RUSCHA, 1966;
screenprint, printed in color;
composition; 19$^1/_2$ x 36$^{15}/_{16}$ in.
(49.5 x 93.8 cm). John B.
Turner Fund, The Museum
of Modern Art, New York.*
Best known for his
series of gas stations,
Ruscha's early training
in commercial art
neatly negotiated a
style of dynamism into
the central message,
where the literal image
is ordinary. He knew
instinctively the conse-
quences of a media cul-
ture based on packaging.

Ex. 4—Trinity's Trine

JESS (Jess Collins), 1964; oil on canvas over wood;
45⅞ x 48⅛ in. (116.5 x 122.3 cm). Purchased with the aid
of funds from the National Endowment for the Arts and an
anonymous donor, The Museum of Modern Art, New York.
Known in the San Francisco Bay area in the 1950s
for creating collages from newspaper comics,
Jess began to make more disjunctive photo-
collaged images, often scrambling words as well
as images. The machine images refer to his own
training, and turn against the logic of science.

Fat Knat

ROBERT HUDSON, 1964; painted steel construction;
55⅛ x 17½ x 53⅞ in. (139.9 x 44.5 x 136.7 cm). Given
anonymously, The Museum of Modern Art, New York.
A California sculptor, Hudson assembled his
pieces from diverse sources in order to retain
a sense of improvisation. Frequently poly-
chromed with bright, gaudy colors, his works
remained awkward compilations that refused to
take themselves, or the notion of art, seriously.

POP ART IN EUROPE

The legacy of materialism in Europe remained from artists like Jean Dubuffet, Alberto Giacometti, and Francis Bacon but, as in the United States, the inner-directed existential angst of the late 1940s and early '50s began to give way to a more external set of concerns.

The European sense of the avant-garde was born from past war-torn destruction as well as the physical rebuilding of cities, infrastructures, and psyches. But the concern for physical prosperity took a number of directions, some diversely experimental, others more conservative, following first in the footsteps of the Americans. Yet it remained unique in its concerns for a rawer materialism, its conceptualism, and social conscience. Although much of European art from the 1960s is known, especially in America, under the generic title "Pop Art on the Continent," the term Pop art cannot be used in the same sense. Given the artistic diversity it is difficult to maintain that any one label can provide an umbrella for the variety of ideas, but the term New Realism comes closest to an historical sense of unity.

In the 1950s painters like Pierre Soulages, Hans Hartung, and Georges Mathieu revived the pre- to late-war materialism of Dubuffet's art brut but without the angst. Concerns such as gesturalism, surface expression, and even beauty marked them as an interesting response to the American action painting of Jackson Pollock, Willem de Kooning, and Franz Kline. Although the French works inspired many European versions of Abstract Expressionism, it was the concept of process more than the actual painting that became the progressive

element within New Realism in the 1960s, much the same as Allan Kaprow had developed Happenings in the United States from the inspiration of Jackson Pollock in motion around his canvas.

In Paris, the gestural performer was Georges Mathieu, frequently painting in front of television and film cameras as a public action. His influence would be felt as far away as Japan, where the Gutai performance group saw him on television in the 1950s.

More interesting than the gestural paintings were the Europeans who were working with a rawer sense of materialism. Artists such as the Catalan Antonio Tàpies and the Italians Alberto Burri and the older Lucio Fontana did not, in the 1950s, simply assert the physicality of the modernist painting surface; through the use of cementlike surface impastos, torn burlap bags, sand, rough gouges, and even torn canvases they transferred concern from the processes of painting to physicality itself. The canvas was simply another object among many, a meeting place for materiality. Equally, but in the tradition of figurative painting, the same sense of physicality was marshaled, as we have seen, by painters as diverse as the CoBrA group and Lucien Freud.

Le Nouveau Réalisme

The concentration on a rawer physicality and the offshoot of gesturalism—action—were diverse tendencies that coalesced around an organized movement in Paris beginning in 1960, complete with critics and manifestoes, under the title New Realism.

Sackcloth

ALBERTO BURRI, 1953; burlap, sewn, patched, and glued, over canvas; 33⅞ x 39⅜ in. (86 x 100 cm). Mr. and Mrs. David M. Solinger Fund, The Museum of Modern Art, New York. One of the most important artists in Europe in the 1950s, the Italian Burri's work employed sackcloth (*sacchi*) and other "debased" materials, which he sutured and collaged into compelling materialist statements.

Saffa Super Match Box

RAYMOND HAINS, 1965; synthetic polymer paint on plywood; 45½ x 34¼ x 3 in. (115.5 x 86.9 x 7.5 cm). Gift of Philip Johnson, The Museum of Modern Art, New York. Best known for his "torn posters" or *affiches lacérées* (décollages), shown well before his joining the New Realists, Hains's matchboxes, first exhibited in 1964, are more typical of Pop art in their appropriation of popular imagery. The name *saffa*, like that of *seita*, was composed from (or "matched") the initials of the tobacco companies in Italy and France.

The majority were French but the banner of New Realism spread to include, in the minds of many, most of the avant-garde on the European continent and to become synonymous with Pop art. But the range here was far greater than found in the United States or Great Britain, far more experimental and concerned with art as a complex set of social ideas.

These artists combined a greater sense of conceptualism in their use of and reaction to the change in the degree of materialism in the modern world. There was little concern with the emergence of a media culture, thus avoiding the narrower concerns of the New York school. Indeed, Yves Klein, the central figure in the movement, was not only the most unusual figure but, ultimately, he opposed materialism except as a means to spirituality. Few have as artfully managed the dialogue between materialism and its opposites. The question then arises: In what ways were they materialistic?

Pierre Restany, the critic who penned New Realism's manifestos, wrote of a generally shared concern for the modern realities—a list that was lengthy and quite open-ended. Admitting their debt to Dada and the use of found objects in the world, they accepted virtually anything that was not part of the art world, aside from needing its existence as a system and an arena for their performances and actions. Thus the spirit of resolute avant-gardism seemed foremost; whatever was new and in the world was their only point of agreement. So torn were they that they dissolved their official movement soon after signing agreements, but the organizing principle of "new realism" followed their diverse developments.

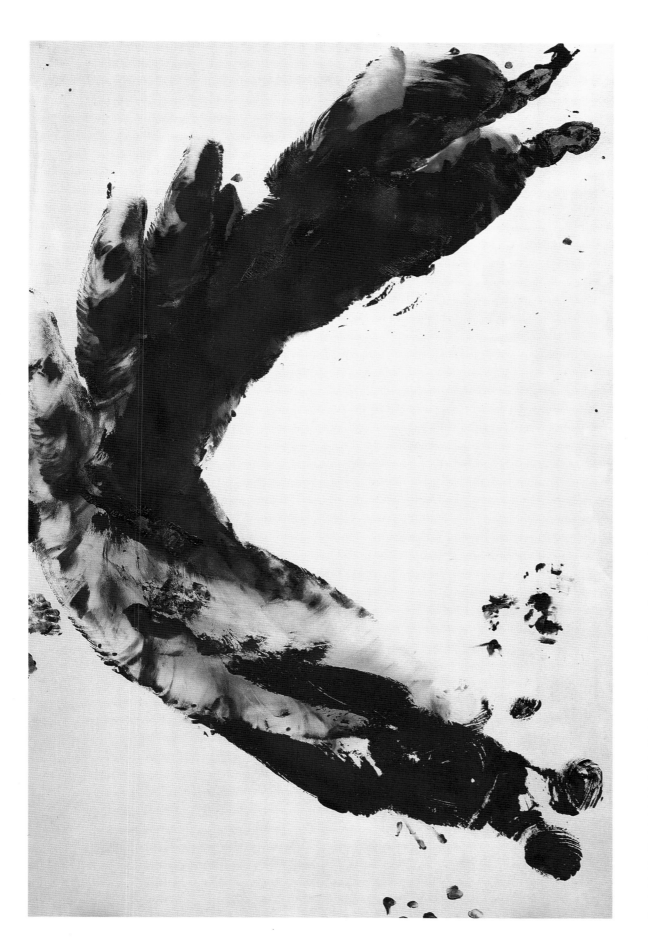

Anthropometry: Princess Helena

YVES KLEIN, 1960; oil on paper on wood; 6 ft. 6 in. x 50½ in. (198 x 128.2 cm). Gift of Mr. and Mrs. Arthur Wiesenberger, The Museum of Modern Art, New York. © 1997 Artists Rights Society (ARS), New York/ADAGP, Paris. Klein "directed" the making of body prints using live, naked female models as brushes. Since he did not touch them, he effectively removed himself, conceptually and mockingly "cooling" the passion associated with painting gestures on canvas, the hallmark of much of the art of that time.

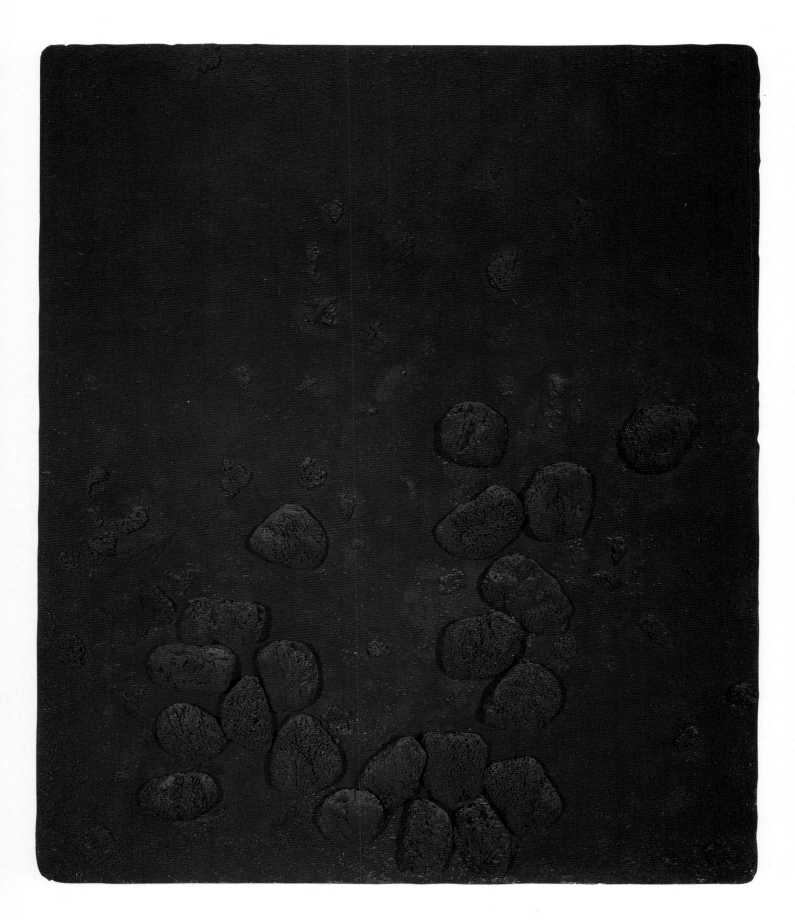

Klein & Conceptualism

Klein had been oriented toward spirituality all his life, with interests ranging widely from comic books to Zen Buddhism. Self-taught as an artist, the core of his aesthetic was quite parallel to the strategic coolness of the American neo-Dada and Pop artists. Klein rejected the materialism and willful processes of the Paris abstract artists in favor of a more refined and controlled use of materials. But, with Klein, where one line ends and another begins is not always clear.

For instance, he is best known as a painter for the consistent use of a particular color of blue paint that when applied tended to unite the most diverse surfaces into a spiritual "void." Thus the roughest of textures, including concrete sidewalks, were covered with International Klein Blue. The same blue was applied to the bodies of female models who then dragged each other across canvases while Klein, in tuxedo, conducted an orchestra in a continuous single "Kleinian" tone.

It is difficult for the contemporary reader to accept these as examples of Klein's cool rejection of personal ego. But the same was true for the extravagant gestures of Marcel Duchamp in the early part of the century when he declared a urinal art. No doubt Klein was most at home with art as a concept, and many of his actions—the removal of all paintings from a gallery, photographs of his "leap into the void" from a second-story window—are seen today as part of the development of conceptual theater and performance art similar to earlier Happenings.

Relief-Eponge Bleue

YVES KLEIN, n.d.; oil on canvas. Wallraff-Richartz-Museum, Cologne. © 1997 Artists Rights Society (ARS), New York/ADAGP, Paris.
The best known of the New Realists, Klein demonstrated the paradox of a movement that defined itself through acceptance of common objects in the world by developing art forms that were conceptual in nature. Klein Blue, his patented color, symbolized immateriality and leveled the field by making one work much like another.

Torso

CÉSAR (César Baldaccini), 1954; welded iron, 30³/₈ x 23³/₈ x 27¹/₈ in. (77.1 x 59.4 x 68.8 cm). Blanchette Rockefeller Fund, The Museum of Modern Art, New York. © 1997 Artists Rights Society (ARS), New York/ADAGP, Paris.
Building up forms from iron scraps and machine parts, César's works, like those of his older French colleague Germaine Richier, stand as metaphors for war-damaged life in Europe. But by the sixties his existential angst had disappeared, and as a New Realist the artist accepted and transformed a wide range of found materials.

New Realism's Materialism

The work of other "members" of New Realism was more concrete, and parallel although not beholden to the junk and assemblage or construction aesthetics that emerged in the United States with artists such as Stankiewiez and Chamberlain. The French sculptor César (Baldaccini) had begun in the 1950s to assemble welded metal figures from scrap metal before moving, independently of and quite different than Chamberlain, to the compact crushing of junkyard automobile parts.

97

Empaquetage ("Package")

CHRISTO. Musée Cantini, Marseille. An associate of the New Realists, Christo is best known today for his large-scale "wrappings" of full-size buildings and other projects in the environment. Packaging the world as a series of objects, however, is more a metaphor of process, pointing out the objectification and social mechanisms within culture.

Valetudinarian

ARMAND P. ARMAN, 1960; assemblage of pill bottles in a white painted wooden box with glass top; 16 x 23¾ x 3⅛ in. (40.4 x 60.2 x 7. 9 cm). Gift of Philip Johnson, The Museum of Modern Art, New York. © 1997 Artists Rights Society (ARS), New York/ADAGP, Paris. Arman's accumulations spread toward the obsessive repetition of singular items as a comment on the accumulation of material objects in the world. Whereas Warhol's repetitions point to the nature of the exterior world, Arman's work points inward to a disturbing sense of the consumer at the heart of the system.

Arman (born Armand Fernandez) was a close friend of Klein's but seemed his opposite. In the late 1950s he began his "accumulations" or *poubelles*—literally, "trash cans." In transparent plastic containers he placed the debris he found in the trash bins of friends. The *poubelles* were not examples of postwar detritus but rather a social perspective, a transparent looking-glass for issues of consumption in a capitalist system by an art system that accepted an anthropological orientation in a culture of abundance. From here, Arman made a career of such accumulations and embedded displays whose obsessiveness was intended to parallel the compulsive-obsessive characteristics of a mass-production culture with a fetish for commodities. His critical social conscience was shared by a number of European artists and this separated

them decidedly from much of New York Pop.

Christo (Christo Vladimirov Javacheff) brought his social values to the Paris-based New Realists via his Marxist education in Bulgaria. He wrapped everyday items in plastic and, later, white canvas, and tied them with ropes. The process turned the commonplace into the mysterious while pointing to the package's sense of being an object. More complexly, these simple beginnings grew into Christo's famous wrappings of entire buildings and large areas of landscape. While it is true the wrapping called attention to certain moments and locations, it was the more involved process of negotiating the rights and permissions, then directing the large squads of volunteers to carry out the projects, that embodied Christo's social concerns. His ability to engage people who

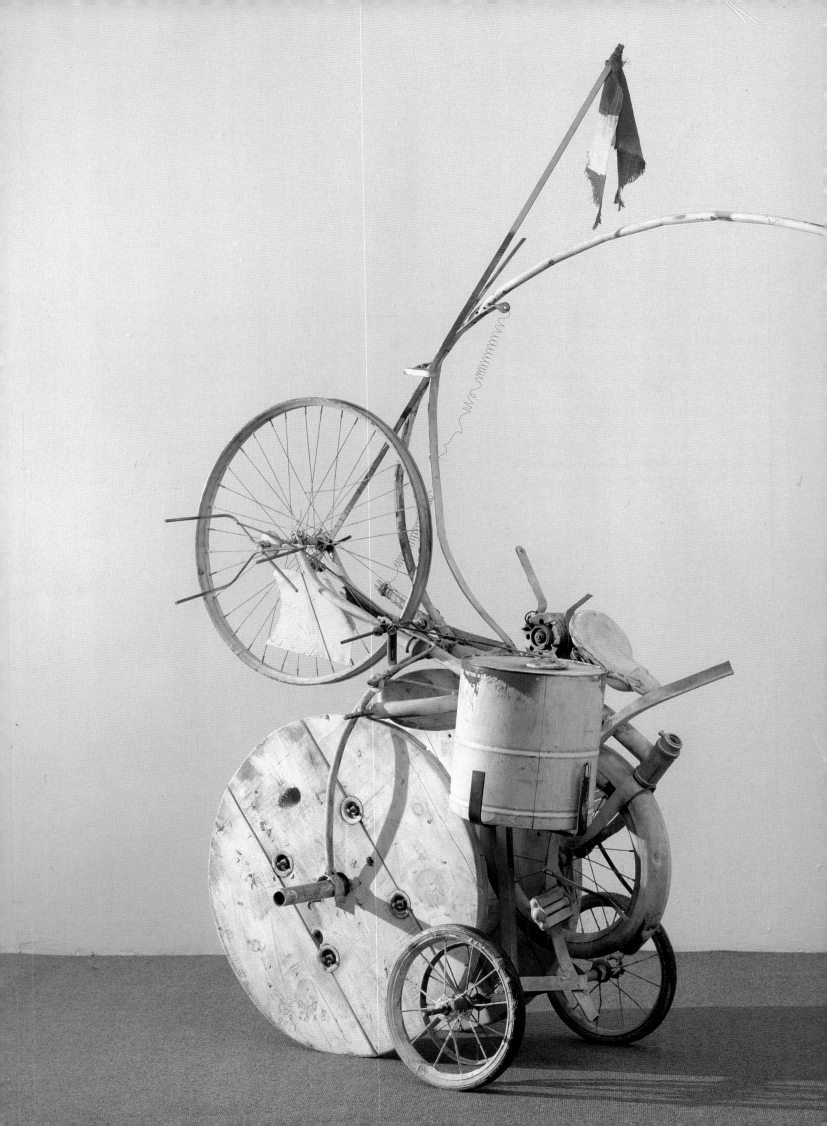

**Fragment
from *Hommage
to New York***

*JEAN TINGUELY, 1960;
painted metal, wood,
and cloth; 6 ft. 8¼ in. x
29⅝ in. x 7 ft. 3⅞ in.
(203.7 x 75.1 x 223.2 cm).
Gift of the artist, The Museum
of Modern Art, New York.
© 1997 Artists Rights Society
(ARS), New York/ADAGP, Paris.*
Working in Europe
with movement, ma-
chine parts, and sound
in the 1950s, Swiss-
born Tinguely was a
Dadaist at heart. His
most famous mechan-
ical performance came
from his machine that
self-destructed in New
York's Museum of
Modern Art, fragments
of which testify to an
objectified event whose
concept remains intact.

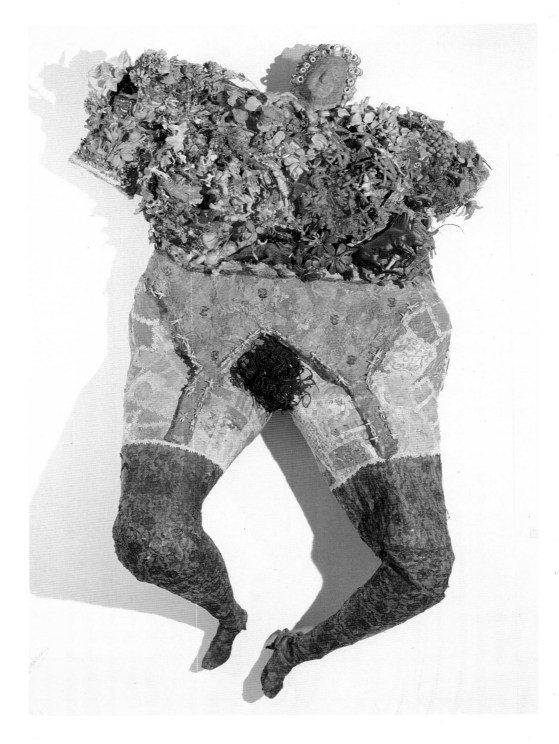

Crucifixion

NIKI DE SAINT-PHALLE,
1963. Musée Nationale d'Art
Moderne, Paris. © 1997
Artists Rights Society (ARS),
New York/ADAGP, Paris.
An American expatriate
working in Europe,
Saint-Phalle created a
series of earthmother
figures, generically
known as *Nanas*, or
"broads," as a mani-
festation of her early
feminism. They cele-
brated their sensuality
through exuberant
poses, gaudy folk-col-
ors, and a blatant dis-
play of their pubic areas.

otherwise had little to do with art in the
negotiations of a place for an art event that at
first made no sense to them was the purpose
of the project as much if not more than the
spectacular wrappings.

Daniel Spoerri took the issue of the spectacle
in quite a different direction and with a concern
for what was "real." He simply froze the re-
mains of dinners he had shared with friends,
complete with dirty dishes and food scraps, in
an effort to entrap a sense of his reality. Dirty
dishes became residual testimonies of an every-
day performance in the world.

Jean Tinguely, a Swiss-born artist obsessed
with motion and transformation along with a
wonderful feeling for the absurd, spent a life
assembling discarded machine parts into active
machines he called "metamatics." They moved,

made noise, could make drawings in a mechanical parody of abstract expressionist gestures, and generally befuddled if not chased after the audience. Perhaps his most famous metamatic was his 1960 *Hommage à New York*, whose dozens of motors, wheels, and junk parts were designed and assembled to play music, create noise and drawings, and ultimately destroy itself in front of an audience, which it did. But it did so on its own terms through the Dadaist elements of chance and self-operated anarchy when it caught fire. Tinguely was reportedly ecstatic.

Among all the New Realists Niki de Saint-Phalle and Martial Raysse came as close to what might be considered Pop art as any in the New Realism movement would. But even here their differences are striking.

De Saint-Phalle was born French but lived in the United States until the early 1950s. She returned to Europe to become a member of the new movement and form a link between American neo-Dada and European New Realism. A friend and collaborator on some of her "process" pieces of burst paint balloons was Robert Rauschenberg, just as Rauschenberg helped de Saint-Phalle's husband, Jean Tinguely, assemble his metamatics in the United States. But de Saint-Phalle moved very quickly into a consistent and unique if outrageous form of sculptural series called *Nanas*, or "Broads." These wire and papier-mâché figures of women were large doll-like constructions painted in garish colors and decorated with patterns and clothing that seemed more like fetish objects. The bloated figures combined humor and razor-sharp satire from a feminist perspective.

The most notorious *Nana* was named *Hon* ("She"). At about 80 feet long and 20 feet high (26 x 6.5 meters), the Broad lay on her back while viewers entered her body through the vaginal canal to find films and a drink bar in her interior. In sharp contrast, there was no feminist attitude present in American Pop art, and women were generally not involved despite

the fact that they were active in other art movements of the era.

Martial Raysse was best known for his acceptance of materials and means employed in the world of kitsch advertising, such as photographic techniques and bright colors that frequently included the garish use of neon. Embedded in his works were images and references to the art world and its traditions, with a fluid transport between the past and the present typical of a here-and-now attitude found in the modern consumerist world. Advertising had co-opted the timelessness of Freud's and the Surrealists' dream-time.

Hygenic Double Portrait of Vision

MARTIAL RAYSSE, 1968; plastic, cloth, and sheet metal. Private collection, New York. © 1997 Artists Rights Society (ARS), New York/ADAGP, Paris. Raysse, known in Europe as the "Matisse of neon and fluorescent painting," not only references in his work Matisse's paper cut-outs, now turned photographic montage, but employs a wide range of modern materials as well. His celebration of kitsch elements echoes the consumer culture.

FOLLOWING PAGE:

Kichka's Breakfast, I

DANIEL SPOERRI, 1960; assemblage: wood chair hung on wall with board across seat, coffeepot, tumbler, etc.; 14⅜ x 27⅜ x 25¾ in. (36.6 x 69.5 x 54.4 cm). Philip Johnson Fund, The Museum of Modern Art, New York.
In 1960, the year he joined the New Realists, the Romanian-Swiss dancer turned artist began his "snare pictures" (*tableaux-pièges*), gluing down or snaring bits of crockery or objects. Often, as here, the objects were leftovers from shared meals, a public event that trapped reality in a spectacle.

Numerous other artists used the issue of photographic reproduction as well, in open recognition of its new role in the culture. The Italian artist Michelangelo Pistoletto mounted figures based on photographs onto highly polished stainless-steel surfaces that acted like mirrors. With life-size images at floor level the viewer became part of the scene, adding his or her own physical presence to the reading of whatever generally implied narrative Pistoletto had mounted. His work was participatory in a unique way and part of the widely shared impulse among neo-Dada, Pop, and New Realist artists to collapse the barriers they felt that art had erected around itself in the 1950s. The issue of reflective but harmless voyeurism also added to the surprise and humor.

A strong sense of social, hence participatory, politics was more typical of Europe than the United States and it found expression in many artists outside the official but related orbit of New Realism. Oyvind Fahlström, a Swedish artist working in New York City in the 1960s and '70s, perpetuated his international perspective by first developing "paintings" that were assemblages of oil and pre-given images, then moving into works that resembled complex board games. They could be read on a number of levels and frequently made parallels via game theory between participatory board games and the "games" played by world governments and their agencies and systems.

The critical social conscience of the Europeans was certainly not a part of New York Pop art but could be found, although not as consistently, in the "funkier" West Coast artists such as Bruce Conner and, especially, Edward Kienholz. But European artists went on to combine their social awareness with a far more developed attitude which placed art as an action in the world. What could be more "real"?

Man with Yellow Pants

MICHELANGELO PISTOLETTO, 1964; collage with oil and pencil on polished stainless steel; 6 ft. 6⅞ in. x 39⅜ in. (200.3 x 100 cm).
Blanchette Rockefeller Fund, The Museum of Modern Art, New York.

The Italian painter Pistoletto began his mirror paintings in 1962, collaging images of life-size figures onto stainless-steel plates. The mirror surface introduced the viewer into the moment and narrative, as well as mixing and muddying the waters between issues of reality and fiction.

Notes 4 (C.I.A. Brand Banana)

ÖYVIND FAHLSTRÖM, 1970; synthetic polymer paint, pen and ink on paper; 16⅝ x 14 in. (42.2 x 35.3 cm).
Mrs. Bertram Smith Fund, The Museum of Modern Art, New York.
© 1997 Artists Rights Society (ARS), New York/VG Bild-Kunst, Bonn.

Fahlström, like many of the New Realists, ranged widely through intellectual history and popular culture, creating loose collages from the images and experiences. Much of it was intricate and puzzling, stubbornly refusing unity, and organized around board games whose game theory paralleled that of its subjects: corporations and the C.I.A.

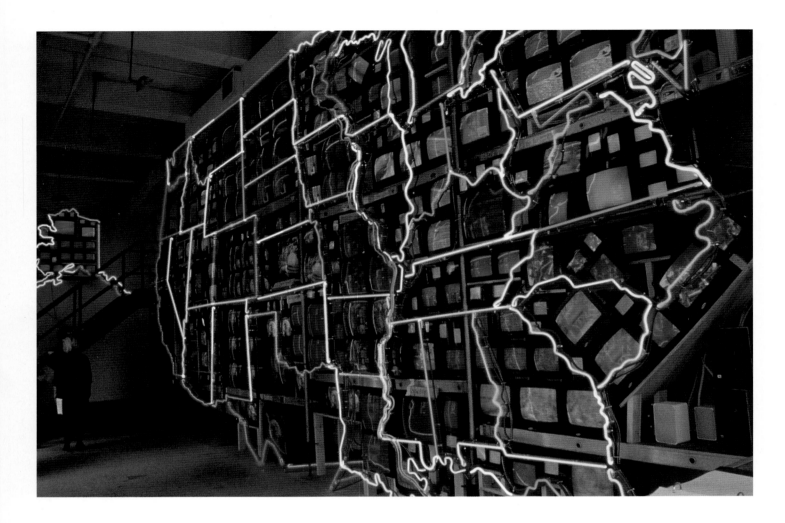

Electronic Superhighway

NAM JUN PAIK, 1995; installation/assemblage;
14 x 32 x 4 ft. (426.7 x 975.3 x121.9 cm). Courtesy
of the artist and Holly Solomon Gallery, New York.
Paik's use of video demonstrates one of the several
ways that performance artists embedded their
interests in art as process through objects. All the
geographical "states" of the United States are repre-
sented in their "states" of mind with videos that
pertain to it; e.g., Wyoming has views from Yellow-
stone Park and Kansas plays the Wizard of Oz.

Fluxus & the Performative

The strong avant-garde impulses toward art di-
rected to social consciousness through concep-
tual and confrontational performances had a
more viable life in Europe and has a history ul-
timately beyond Pop art and New Realism.
However, its roots were here in the 1960s
among those who accepted the realities of the
given world. Chief among these was the Fluxus
movement, emerging partially from what was
happening in the United States but first codify-
ing in Germany, then spreading through
Europe and back to America.

In testimony to the complex relations among
the international avant-garde, it was the
European tradition of art as an "event" from the
first half of the century that motivated the de-
velopment of Happenings in the United States
in the late 1950s. Although Allan Kaprow con-
tinued staging Happenings into the 1970s,
most of the Pop artists abandoned them by
1962 in favor of making objects. Other artists
moved into a new version, less spontaneous
than Happenings, more directly staged, that
would be termed Performance art and become
a mainstay of the avant-garde on both sides of
the Atlantic.

In Europe, the cornerstone was Fluxus,
whose very name stated their broad-based aes-
thetic to mingle objects and people in greater

abandon and free-form than had been done in the scripted Happenings. In New York George Maciunas was influenced by the musical events of Cage, which had become the focus for a gathering of international conceptual artists. Maciunas then went on to open his own gallery, host similar performances, and in 1961 invited Nam June Paik, the musician-conceptual performer and a friend of Cage, to help found a performance group called Fluxus that went on to become an international movement beholden to no one continent or country. Music, in its freest and most anarchistic form, provided the paradigm for many of their theatrical gatherings. To this they added the freedom of the New Realists to use any objects in the world.

Paik, by 1962, shifted his neo-Dada orientation first to television and then to video installations. The technology of the media culture was here, as for Pop artists, part of the everyday environment. Paik simply acknowledged and updated the fact more literally by using television sets and their signals as objects. Joining the Fluxus events in Europe was another musician for whom music and conceptual freedom was important, the German Joseph Beuys. For Beuys, objects such as felt, fat, and lead took on a mystical presence as he used them in performances. His art and ideas inspired an entire new generation of European artists to explore materialism in symbolic and conceptual ways.

Repository

GEORGE BRECHT, 1961; assemblage: wall cabinet containing pocket watch, tennis ball, etc.; 40³/₈ x 10¹/₂ x 3¹/₈ in. (102.6 x 26.7 x 7.7 cm). Larry Aldrich Foundation Fund, The Museum of Modern Art, New York.
Brecht studied music with John Cage and was an active member of Fluxus into the 1970s. His assemblages of memory and mystery, begun around 1960 and made from found objects set within wooden boxes, formed an ongoing work-in-progress.

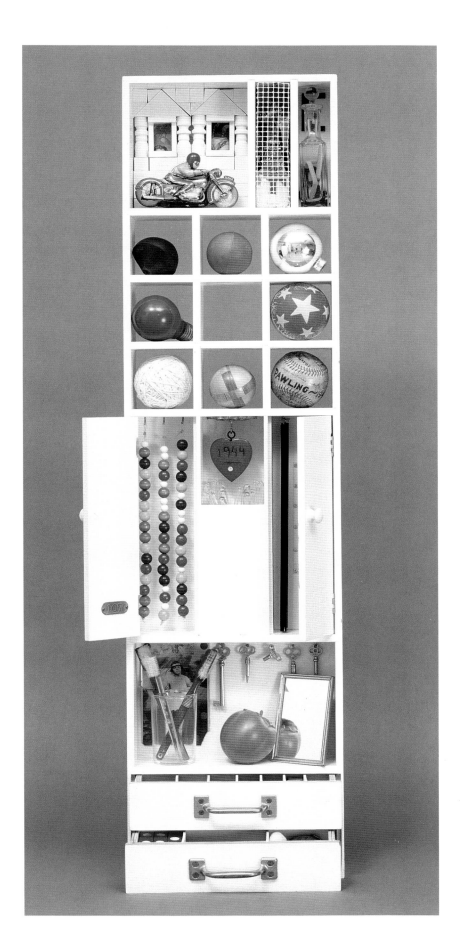

The complex ties continued. Some of Cage's events around 1960 were staged in the New York loft of the Japanese conceptual artist Yoko Ono, who later participated in Fluxus events. It was her conceptual attitude toward objects that attracted musician John Lennon, later her husband, who himself had been a part of the Liverpool art scene where the first multi-media events emerged in 1962. Thus Fluxus was never a clearly defined group or membership but it was an extremely important birthing ground for the international conceptual art movement.

This was, to slightly misuse the phrase of another historian, art in the theater of real events. And it is impossible to understand the work of European postmodern artists of the 1960s, such as Sigmar Polke and Gerhard Richter, without acknowledging the merger of the apparent contradictions that occurred here: object and concept, stasis and action. Much of

Friends

Sigmar Polke, 1967; photolithograph, printed in black, composition; 18⁵/₁₆ x 23¹/₄ in. (46.6 x 59 cm). Richard A. Epstein Fund, The Museum of Modern Art, New York. Polke's use of grids and dot patterns in the 1960s referred to the physical act of reproduction rather than expression or personal commitment, a state reinforced by the choice of banal subject matter. High art chose not to manipulate the cliché into anything but what it was.

Abstract Painting (726)

Gerhard Richter, 1990; oil on canvas; 98¹/₂ x 137³/₄ in. (250 x 350 cm). The Tate Gallery, London.
Richter, with Sigmar Polke in the 1960s, negotiated a stereotypical art for a world fixated on signs and standardized types. The knowledge of these conceptual underpinnings—his own history—belies the stereotypes of beauty, color, and gesture to which his works of the 1990s refer.

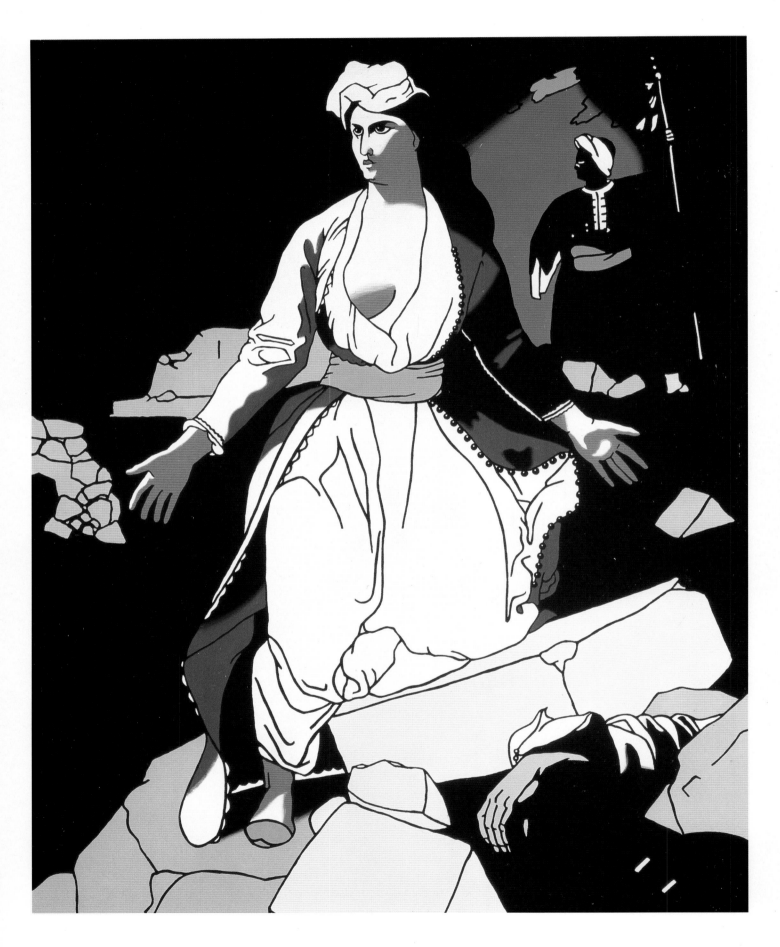

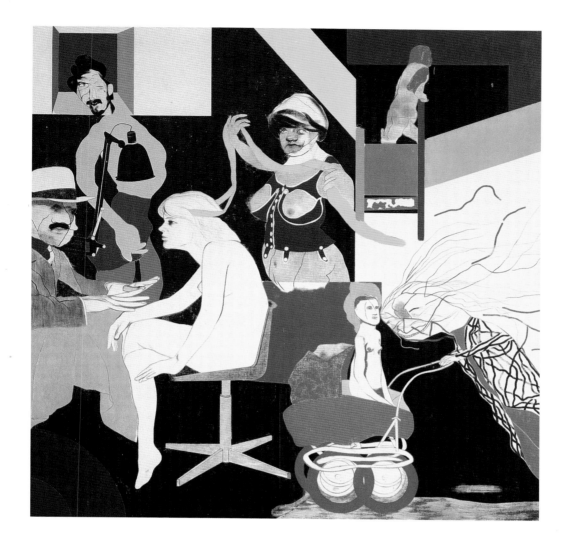

The Ohio Gang

R. B. KITAJ, 1964; oil and graphite on canvas; 6 ft.⅛ in. x 6 ft.¼ in. (183.1 x 183.5 cm). Philip Johnson Fund, The Museum of Modern Art, New York. More an outside influence on Pop than an insider, the older American Kitaj working in London was closest to the movement when using images blown up from photographs and movie stills, as well as his silkscreening. His concerns for the relationships between media and quasi-narrative scenes mark him as distinct.

postmodern art sees, accepts, and utilizes this basic instability in what others perceive as a stable world. Both Polke and Richter frequently employ a luxuriant sense of physical reality in their work to fashion their critique against the litany of ideologies used by the avant-garde art world. In their work, Pop art figures or pedestrian images are used but are intended as an attack on the coherence of Pop art ideas and stylizations. The language and ideas of one movement became the self-conscious dead pan for another.

England

When Alloway developed the term "Pop Art" in the mid-1950s in England it emerged from a concern by the artists for issues within popular culture rather than within art. The generation of artists from the 1950s who formed the "Independent Group" (IG), of which Alloway was a part, celebrated their working-class roots with a purposeful anti-intellectualism by accepting the mass media. Popular films, science-fiction, and advertisements commingled with more advanced ideas on structural systems and engineering, cybernetics, and the impact of the French art brut theory which praised the value of the cast-off.

Greece Expiring on the Ruins of Missolonghi, After Delacroix

PATRICK CAULFIELD, 1963. The Tate Gallery, London.

© 1997 Artists Rights Society (ARS), New York/DACS, London.
A member of the later British Pop movement, Caulfield frequently reached out to encompass master painters of the past, reconfiguring their works through his graphic, commercial stylizations. Such concern for history was unusual although not unique; more common was the use of style as subject.

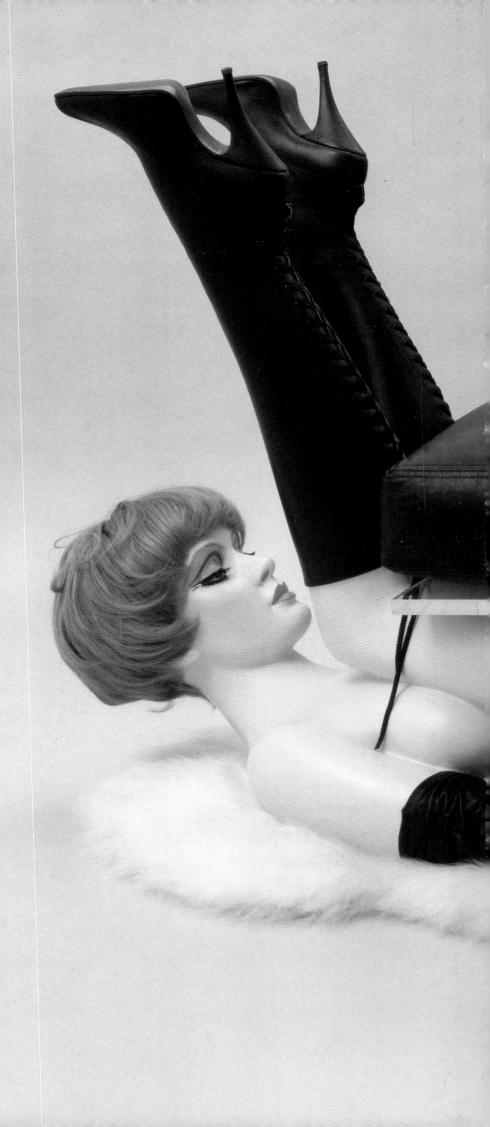

POP ART

Chair

*Allen Jones, 1969; painted
fiberglass and hair, life size.
The Tate Gallery, London.*
Far more provocative
than Tom Wessel-
mann's nudes, Jones's
furniture made on the
bodies of life-size nude
female figures clearly
objectifies them as
erotic objects. Their
subjugation is through
both physical posture,
evoking the role of the
male artist, and the so-
cial, as furniture, in-
voking culture at large.

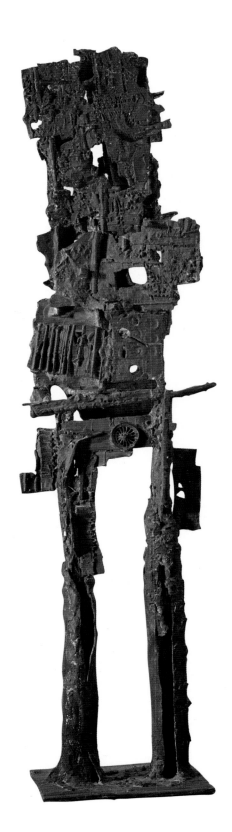

Jason

Eduardo Paolozzi, 1956;
bronze; 66⅛ in. high
(167.8 cm), at base
14¾ x 11¼ in.
(37.5 x 28.6 cm). Blachette
Rockefeller Fund, The
Museum of Modern Art,
New York. © 1997 Artists
Rights Society (ARS),
New York/DACS, London.
In London Paolozzi
marshaled the "slag"
look of Dubuffet,
whose work inspired
him while visiting
Paris, into robotlike
figures whose bodies
and style ranged be-
tween sci-fi horror and
technological scrap
yard—all metaphors
for the past and future
urban condition shared
among the British
Independent Group.

When John McHale left London in 1955 for a year at Yale University to study color theory, he returned not with formalist theories but with the discovery of American diners and his treasure chest of glossy magazines and advertisements from American commercial culture as the basis for his art. Eduardo Paolozzi, who knew Dubuffet from a two-year stay in Paris and had been making collages from commercial advertisements since the mid-1940s, had explained his assemblage aesthetic to McHale and his colleagues in the IG in 1952, ten years prior to such developments in the United States. Paolozzi's scavenger attitude is equally obvious in his bronze sculptures which look like robots formed through some mysterious process of technological accretion.

Paolozzi's collages inspired Richard Hamilton to use the terms of advertising to mock and celebrate the inane but "real" conditions of the postmodern world. Hamilton had one eye toward mass ads, a field in which he at one time worked, and the other eye on Duchamp, whom he studied and idolized. He went on to create complex icons in art that used advertising's own yoke of sex products and consumer desire. *$he*, an oil and collage work two years in the making, placed a fantasy toaster-vacuum combination with the efficiency of a new refrigerator, in front of which stands *$he* with breasts and low-cut dress back collaged from white plywood, neither of which are what they seem. As the titles of two of the IG's famous exhibitions announced, tongue-in-cheek, "This is Tomorrow" here today in a "Parallel of Life and Art." It was to be a tomorrow, a life, and an art new to the planet!

Alloway admitted that these were not Pop artists per se, in the New York sense of the term. Those Britishers were yet to come but Hamilton and Paolozzi had pointed to the new "aesthetics of plenty" as an accepted source for art for the next two generations of English artists.

I Was a Rich Man's Play Thing

EDUARDO PAOLOZZI,
1947; collage on paper;
(35.5 x 23.5 cm). The Tate
Gallery, London. © 1997
Artists Rights Society (ARS),
New York/DACS, London.
Paolozzi was the first
among the Pop artists
in London, or any-
where else, to both use
advertisements from
popular culture and de-
velop a philosophy that
argued for the accep-
tance of the trivial
and banal. Calling the
world they represented
"bunk," he led Pop
art along a fine edge.

Custom Painting No. 3

PETER PHILLIPS, 1964–65; oil on canvas; 84 x 69 in.
(213.3 x 175.2 cm). Collection Watson Powell, Des Moines, Iowa.
As a result of his two-year visit to New York, from 1964 to 1966, third-
generation London Pop painter Peter Phillips's airbrushed, hard-edged,
brassy pop fantasies parallel American developments in both the fine arts
and California custom paint jobs. But the use of techno-pop icons was
already a major ingredient in the swingin' London art and design scene.

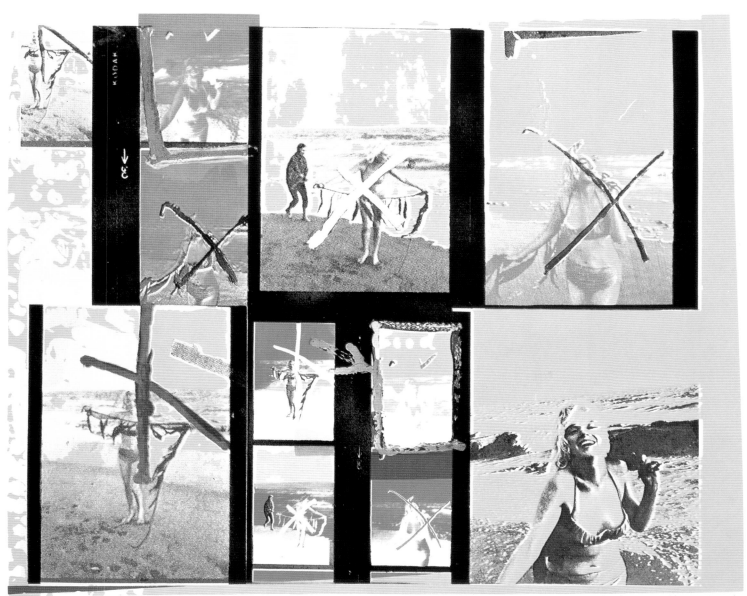

My Marilyn

RICHARD HAMILTON, 1965; screenprint on paper;
20¼ x 24½ in. (51.8 x 63.2 cm). The Tate Gallery, London.
© 1997 Artists Rights Society (ARS), New York/DACS, London.
One of the world's earliest Pop artists, Hamilton
was a member of the London Independent Group
and turned, by 1963, from painting popular images
in fragmentary form to screenprinting them. Screen-
print allowed another layer of experimentation, often
the incorporation, as here, of actual photographs.

FOLLOWING PAGE:

$he

RICHARD HAMILTON, 1958–61; oil, cellulose, collage on wood; 101½ x 81¼ in. (260.4 x 208.3 cm).
The Tate Gallery, London. © 1997 Artists Rights Society (ARS), New York/DACS, London.
Hamilton investigated the clichés of the modern culture, including that of women
and their roles as depicted through advertising images. Here *$he* lies somewhere
between sex goddess and refrigerator, but in either case simply another object.
Note: Image orientation is vertical, with the toaster appearing on the bottom.

Pool Mantra

Joe Tilson, 1976;
print with mixed media.
The Tate Gallery, London.
Objects and words,
like daily events,
repeated in a cycle
become mantras of
the everyday. Tilson,
a London Pop artist,
dedicates a great
deal of his art to such
cycles, while calling
equal attention to the
making and coloring
processes that
construct his own
daily references.

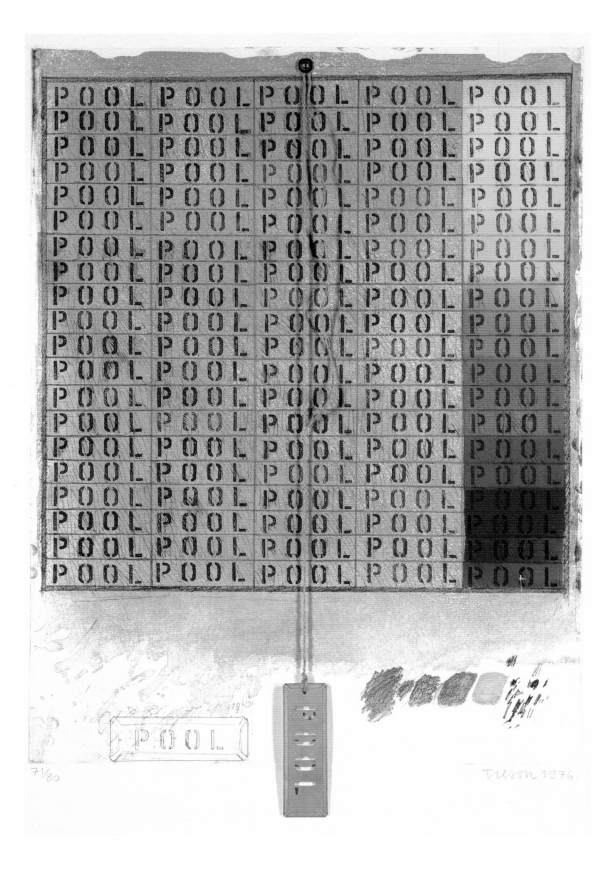

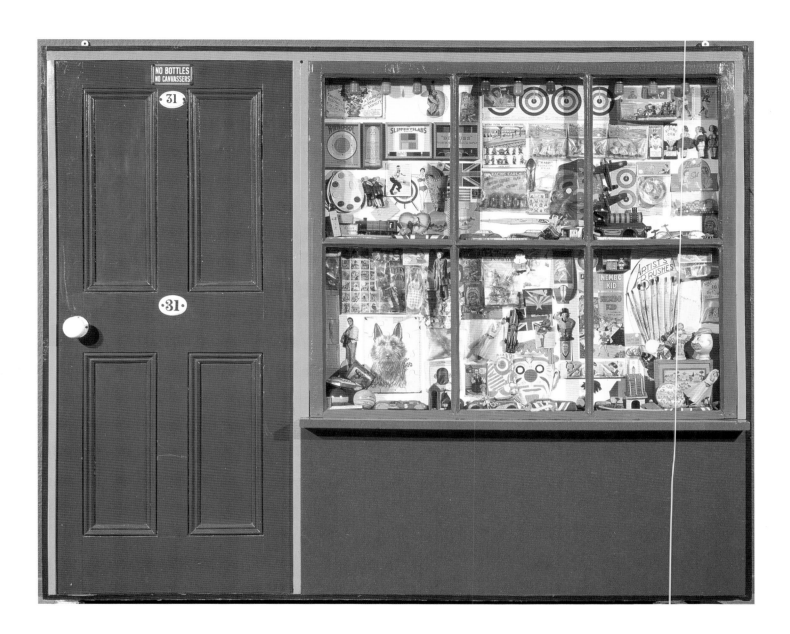

Peter Blake was perhaps the most famous of the second generation and a work such as *Got A Girl* exemplifies British Pop art of the 1960s. The "stars" are photo collages of famous white American rock-and-rollers, while the real 45 r.p.m. record in the upper left refers to the song by the Four Preps of a girl who thinks only of stars when she is with her boyfriend. The gossamer quality of reality! Nor was the tie to music fortuitous. The Beatles had Blake design the collage to their 1967 *Sergeant Pepper's Lonely Hearts Club Band* album cover in testimony to their common roots as art students coming of age in a newly media-saturated culture.

Toy Shop

PETER BLAKE, 1962; relief in mixed media; 61⅛ x 75½ x 13¼ in. (156.8 x 194 x 34 cm). The Tate Gallery, London.
© 1997 Artists Rights Society (ARS), New York/DACS, London.
Blake was an admirer of the work of his fellow Englishmen Lewis Carroll and William Shakespeare; he loved their sense of fantasy, something he himself never lost. Homage is paid to the realm of fantasy in this meticulous recreation of a child's fantasyland.

Got a Girl

PETER BLAKE, 1960–61;
enamel, photo collage and record;
3 ft. 1 in. x 5 ft. 1 in. x 1⅝ in.
Whitworth Art Gallery,
University of Manchester.
© 1997 Artists Rights Society
(ARS), New York/DACS, London.
In 1959 Blake began using
icons of the new era—here
Fabian, Frankie Avalon,
Rickie Nelson, Bobby
Rydell, and Elvis Presley—
to testify to the merger of
entertainment, art, and
fame. The new generation
would go on to live much
of its life guided by the
emotional expressions
found in records, such
as the one mounted here.

From the third generation, the work and reputation of David Hockney has endured, partly because of his move to the United States, the country that often exerts the biggest impact on press and publicity. Famous before he left art school in 1962, he became an English-styled Andy Warhol with a working-class accent installed on the scene of swinging London. But the guise did not hide the talent; indeed his flamboyance was a tribute to his predecessors' lessons—to accept the world around oneself and follow one's own taste. His work ranged from graffiti-like expressionism to highly naturalistic drawings and from flat, planar shapes of simplified color to the later use of collaged photographs; all of these were Hockney and all of them acceptable to a multi-talented artist who lived fully within a multivalent world.

Truth in Packaging

From Hockney back to Duchamp and ultimately across the industrialized world Pop art was, and to some extent remains, a visual embodiment and conceptual lesson about the

Man in Shower in Beverly Hills

DAVID HOCKNEY, 1964; acrylic on canvas; 65½ x 65½ in. (166.3 x 166.3 cm). The Tate Gallery, London. Moving from London to Los Angeles in 1963, Hockney became the quintessential chronicler of the LA scene, with its moderne homes and palms, pools, and tanned citizens set within uniform light and open spaces. Part cultural observer, he has noted how "Americans take showers all the time."

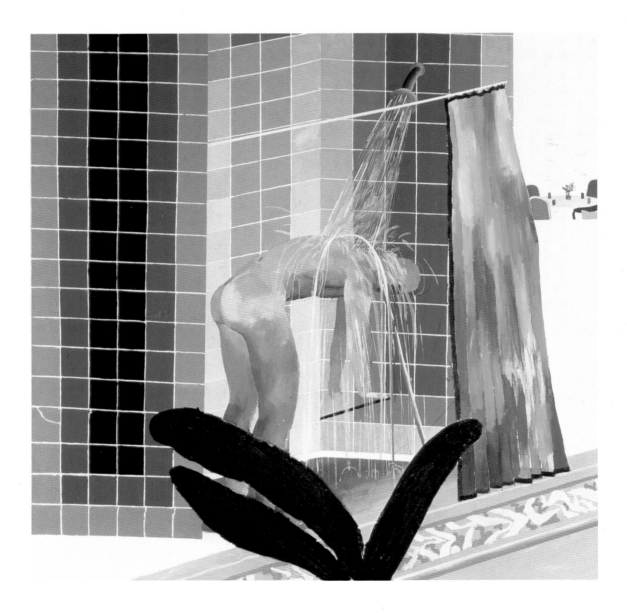

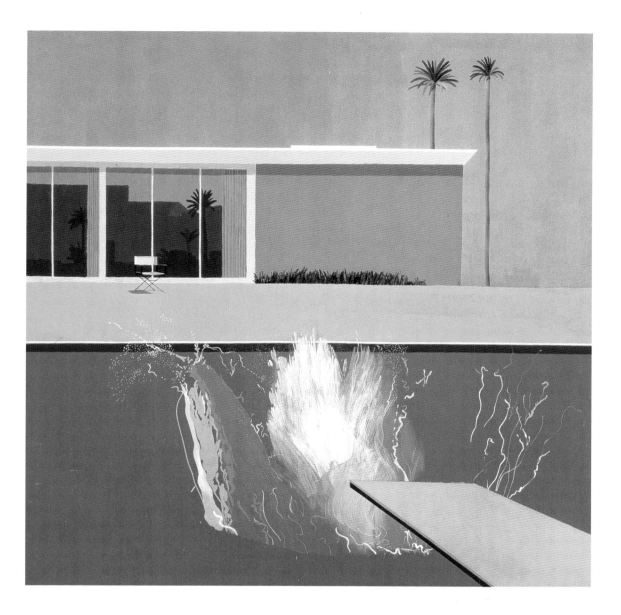

A Bigger Splash

DAVID HOCKNEY, 1967;
acrylic on canvas; 96 x 96 in.
(242.6 x 243.8 cm).
The Tate Gallery, London.
Hockney developed
a graphic style that
echoed the Californian
atmosphere and the
region's affluent
lifestyle—light, airy,
simple areas of color
with an emphasis on
patterns. Style func-
tioned as an ideology
and was an integral
part of the content.

nature of the new culture of the twentieth century. Not only did the specific meaning of things change over time, as one expects, but meaning itself became problematic. From Dadaist play, to the 1930s invention of propaganda, to the ubiquity of commercial imaging in the 1960s, meaning has been re-cognized as a process, a construction, rather than a given or singular truth.

The new conditions of physical multiplicity in the world most certainly brought a multiplicity of meaning. But the conditions chronicled in and through Pop art refer not simply to the mass production of goods and multiple claims made for them but are derived from the fuller understanding of a basic instability inherent in any construction used to communicate—be it images or words. Once realized, the adult practice of forging identity and meaning through denial or selective forgetfulness became less available and more difficult to those raised in the conditions of a media culture.

Perhaps this is the final message to and from the youth culture that found and defined Pop art and in so doing reshaped the history of art and culture for the next thirty years. But as long as mediated cultures re-present themselves to themselves in such great quantities, the consequences of Pop art will continue to challenge what—and, more importantly—how we come to make such claims of knowledge. The truth to packaging is that once empowered, it remains so.

INDEX